CAMBRIDGE
MAIN LINE
THROUGH TIME
PART 1: CHESHUNT
TO AUDLEY END

Andy T. Wallis

AMBERLEY PUBLISHING

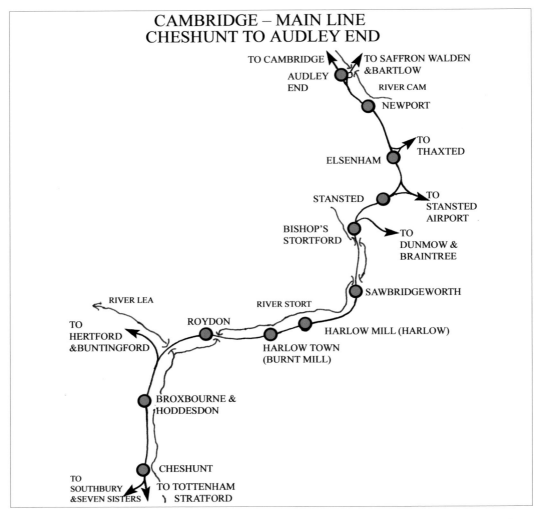

To all Cambridge Main Line railwaymen, past, present and in the future, who keep the wheels turning come rain or shine.

First published 2012

Amberley Publishing
The Hill, Stroud, Gloucestershire, GL5 4EP
www.amberley-books.com

Copyright © Andy T. Wallis, 2012

The right of Andy T. Wallis to be identified as the Author of this work has been asserted in accordance with the Copyrights, Designs and Patents Act 1988.

ISBN 978 1 4456 0767 2 (print)

British Library Cataloguing in Publication Data.
A catalogue record for this book is available from the British Library.

Typesetting by Amberley Publishing.
Printed in Great Britain.

Introduction

The line included in this volume had its origins in the Northern & Eastern Railway, sanctioned by Parliament on 4 July 1836 to build a 53-mile railway from Islington to Cambridge, following the valleys of the Rivers Lea, Stort and Cam for most of the way. The company had an authorised share capital of £1.2 million; a considerable sum in those days.

Construction commenced in 1839, when the original route was modified to run from Tottenham to Stratford and then share Eastern Counties' metals for the run into Shoreditch (London). Opened in stages, the Northern & Eastern Railway reached Broxbourne and Hoddesdon on 15 September 1840; this also included Cheshunt station south of Broxbourne, Harlow (Mill) in early 1841 and a temporary terminus at Spelbrook in November 1841. Six months later the line opened to Bishop's Stortford, the then terminus, as a further Act of Parliament had been granted in 1840 abandoning the proposed route on to Cambridge.

The Northern & Eastern obtained new powers to extend their line from Bishop's Stortford to Newport in 1843 and it had also, late in 1843, leased itself to the Eastern Counties Railway effective from 1 January 1844. This lease passed to the Great Eastern Railway (GER) in 1862 and the old N&ER was not finally wound up until 1902.

Further powers allowed for an extension from Newport to Brandon via Cambridge and Ely and from Norwich to Brandon. The whole route was opened between Bishop's Stortford and Norwich on 30 July 1845, including the remaining stations to Audley End covered by this book.

Passenger and freight traffic developed quickly on the new route, but the track was not up to standard in the early years; a London to Cambridge fast service took nearly 100 minutes to cover the 56 miles. Track and signalling improvements brought this figure down to just 75 minutes by 1905. Similar timings are achieved today on fast services.

Congestion on the route was caused by the ever-increasing freight traffic. Refuge sidings were provided at Broxbourne, Roydon, Harlow, Spelbrook and Elsenham. After leaving the valley of the River Stort, the line climbs over the high ground, the summit being at Elsenham, before descending into the valley of the River Cam at Newport.

Under the London & North Eastern Railway, new signalling, together with some of the refuge sidings which were converted to goods loops, was completed, Bishop's Stortford receiving two new signal boxes and Elsenham receiving a new, enlarged, forty-five-lever box.

Major investment by the LNER was mostly centred on the GE main line via Ipswich and the GN main line to York and Scotland, and it was not until British Rail days that it was announced that

the north-east London electrification programme would include Hertford and Bishop's Stortford and the reopening of the line via Southbury to passengers. Also included in the package was the resignalling of the line with three- and four-aspect colour lights, worked from some of the existing signal boxes. Broxbourne and Harlow Mill received new power signal boxes.

The scheme came on line on 21 November 1960. Bishop's Stortford benefited from a remodelling that raised the speed through the station. Brand-new stations were built at Broxbourne and Harlow Town, provided with two island platforms and lifts to service them from the booking halls.

Trains usually joined and divided at Broxbourne from the beginning of the new service until the Lea Valley was electrified in 1969. All trains met at Broxbourne for interchange purposes after that. Harlow had been designated a new town in 1947, and from a population of 4,500 in 1950 it now has over 110,000 persons in 2012. Further development has been put on hold at the moment.

Branches were provided from the main line to Hertford East in 1843, from Bishop's Stortford to Dunmow and Braintree in 1869 and to Saffron Walden in 1865 – later extended to Bartlow to connect with the Stour Valley line. The Elsenham and Thaxted Light Railway opened from Elsenham in 1913 and lasted just forty years, closing completely in 1953.

Electrification north to Cambridge was authorised in the early 1980s, and the line was resignalled between Bishop's Stortford and Cambridge in advance of the electrification. Freight traffic over the line peaked in the early 1980s, but has since declined to just a few block loads today.

Opening of the brand-new railway to Stansted Airport in 1991 has seen passenger usage over the lines to London and Cambridge increase dramatically; resignalling of the route south of Bishop's Stortford by 2003 has seen the closure of the remaining signal boxes. Finally, recent investment has seen new rolling stock on the line.

ATW
September 2012

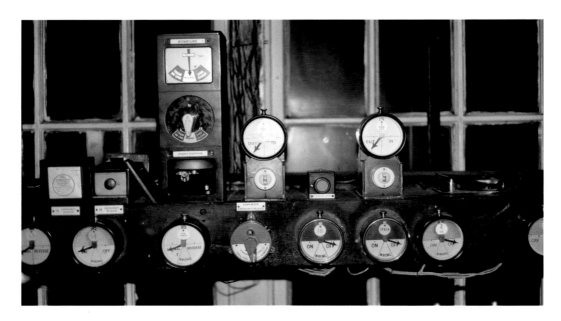

Interior view of Stansted signal box in 1983. (Mick Barnes)

Cheshunt

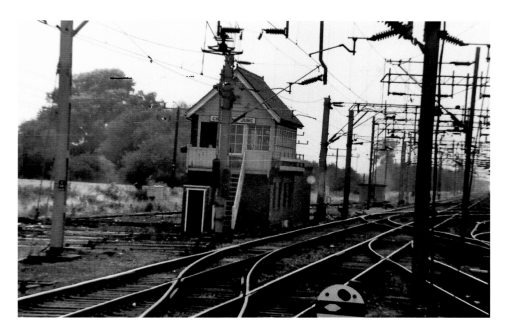

Above: An early 1970s view of Cheshunt Junction signal box hidden amongst the overhead line masts, located at the London end of the station where the main line via the Lea Valley and the Southbury loop diverge. The signal box used to contain a sixty-four-lever frame, with only one spare lever in 1969. The frame was replaced with a small panel in December 1974 until this too was abolished when control of all the signalling was transferred to Liverpool Street. (Nick Ellis)

Right: Today the signal box is all boarded up, awaiting its fate. The junction layout has been simplified, with the train seen taking the Southbury route. The signal in the foreground is a modern LED-type signal. (Andy T. Wallis)

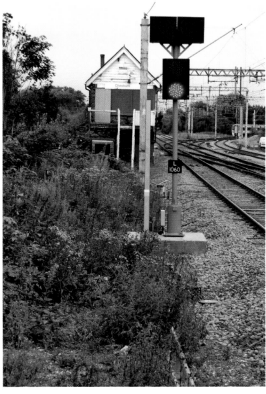

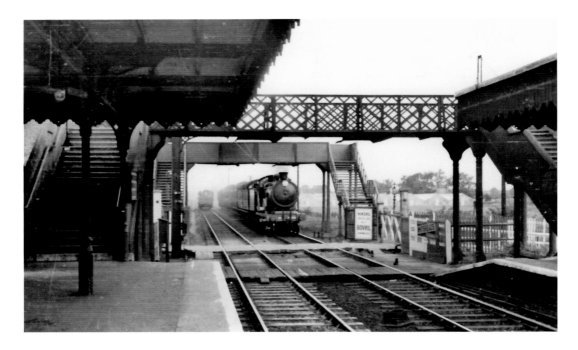

The original Cheshunt station, with large wooden canopies and lattice-style footbridge, is viewed looking north. A passenger train hauled by a B12 locomotive is just about to pass over Windmill Lane level crossing, *c.* 1936. (Stations UK)

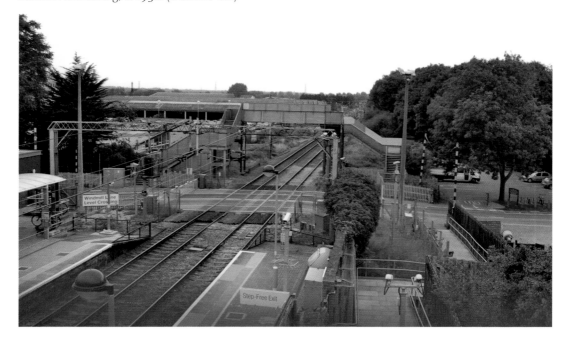

An elevated view looking through the security mesh on the new footbridge clearly shows the level crossing at the end of the station. Disabled access has been provided to the Up direction London-bound platform. (Andy T. Wallis)

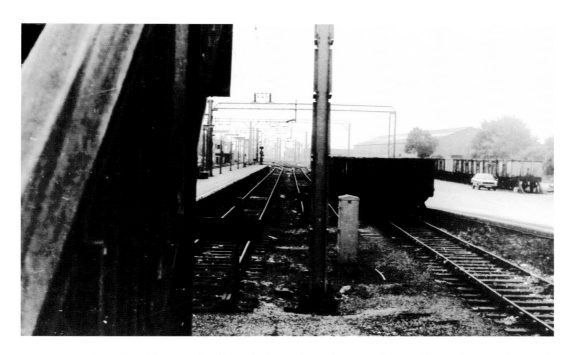

A view from the old station buildings looking along the Down bay platform, showing the goods yard with some sidings in the early 1970s. At this time the station was still receiving wagon load traffic. (Nick Ellis)

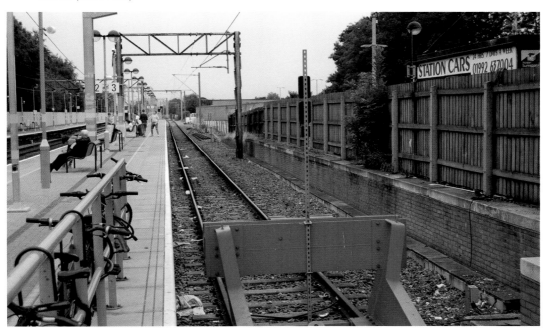

Today the sidings have all been removed and the land turned into a car park and area of commercial use. The Down bay platform has been extended at both ends and can now hold an eight-coach electric train. Access to this platform is from the Southbury loop line only. (Andy T. Wallis)

A very old view of a Great Eastern Y14, later LNER J15, locomotive shunting wagons in the goods yard. The line straight ahead is the main line route up the Lea Valley to Tottenham, Stratford and London. The edge of the signal box can just be seen on the left of the picture. This view is dated 1911. (Historical Model Railway Society)

Today the goods yard is gone, now a car park and large retail unit. The junction track layout has been simplified, with just two crossovers and the double junction. A turn-back signal has been provided on the Down main platform. (Andy T. Wallis)

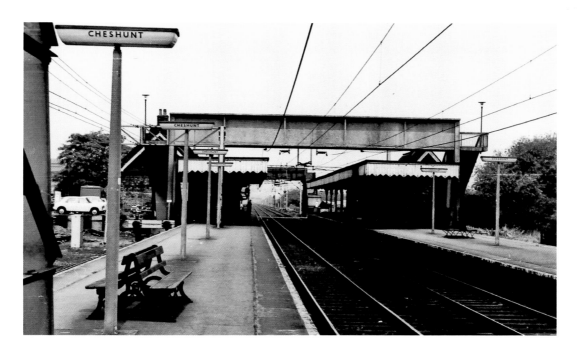

A view along the Down platform showing the original replacement footbridge, installed for electrification, and the original station buildings and canopies. The bay platform is left in this view. This was an official visit to the station prior to the buildings being demolished and replaced with modern buildings. (Nick Ellis)

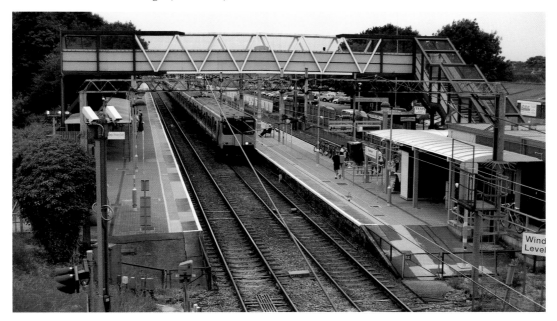

A contrasting view taken from the public footbridge adjacent to Windmill Lane level crossing shows a local service arriving in the platform. Cheshunt is now on its second set of replacement buildings, together with a new footbridge. (Andy T. Wallis)

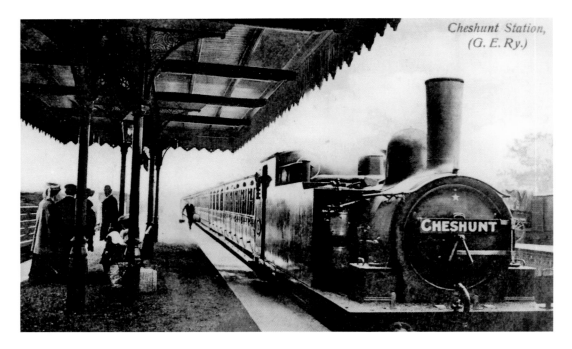

Cheshunt Station, (G. E. Ry.)

Old picture of a steam passenger service in the Down bay platform. The locomotive is a Class F6 and was fitted with air brakes for working GE stock. The actual date of this view is not known. (Lens of Sutton Collection)

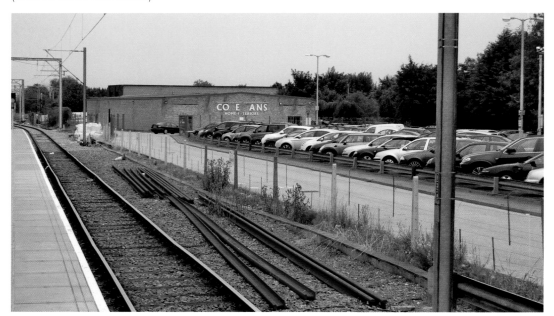

From approximately the same position; the Down bay platform still exists, but on the day of this view there was no local service train to photograph as there was overhead line damage and the train service was somewhat disrupted. As can be seen, the old goods yard now is an access road to the retail unit and the rest has been turned over to car parking. (Andy T. Wallis)

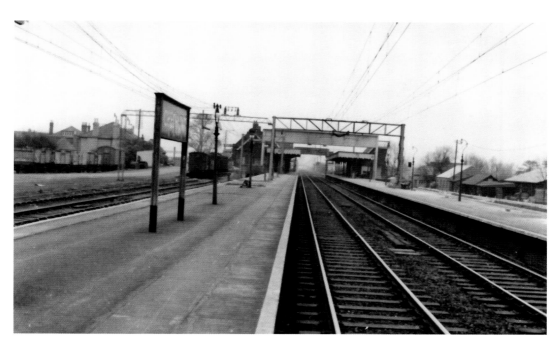

Above: Another 1960s view, taken from the London end of the station, looking northwards towards Broxbourne. Some empty trucks and vans can be seen in the goods yard on the left. (Lens of Sutton Collection)

Right: Today's photograph, taken from a similar position, shows the extended bay platform and new buildings. All the sidings in the goods yard have been lifted and the area given over to a car park for the commuters. On the day of my visit the local train service that used the bay platform was suspended due to overhead line problems on the Lea Valley line. (Andy T. Wallis)

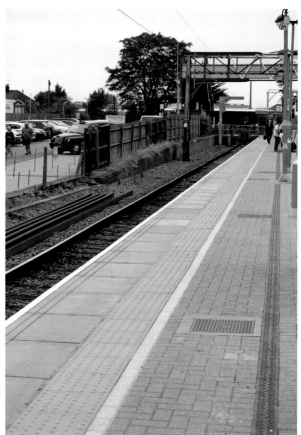

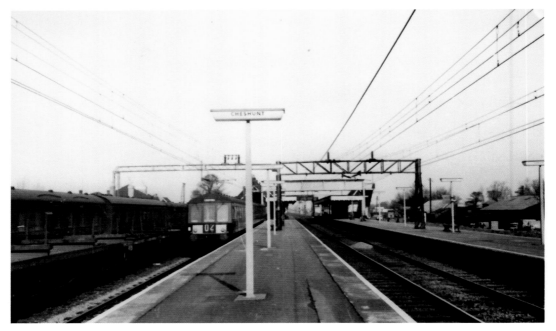

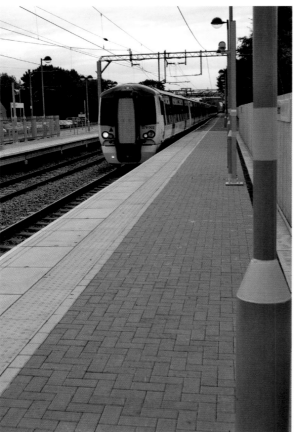

Above: 1963 view of a Derby Heavyweight-type diesel multiple unit standing in the bay platform, with plenty of freight vehicles standing in the goods yard. DMUs were used on the local service along the Lea Valley line, which at this time was not electrified. These services would connect at Cheshunt with the Hertford and Bishop's Stortford electric service, which in turn would divide at Broxbourne. (Stations UK)

Left: Contrasting view of the latest rolling stock on the line; a Class 379 EMU that works Cambridge and Stansted Airport services. (Andy T. Wallis)

Broxbourne

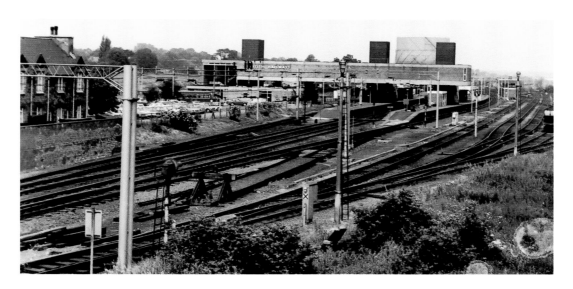

View from the adjacent road overbridge of Broxbourne station buildings and platforms. This station was provided as new in 1960 for the electrification, the old station being situated a couple of hundred yards to the south, adjacent to the road overbridge. During the 1960s, electric train services attached and detached here; after the Lea Valley line was electrified this practice ceased. (Nick Ellis)

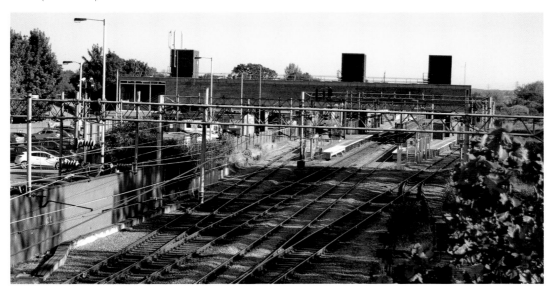

Though unable to get the exact position due to vegetation growth, this is the view today. The inner faces of both platforms have been extended at both ends to take twelve-coach trains. The old station's houses on the right have been demolished and the area turned into car parking. (Andy T. Wallis)

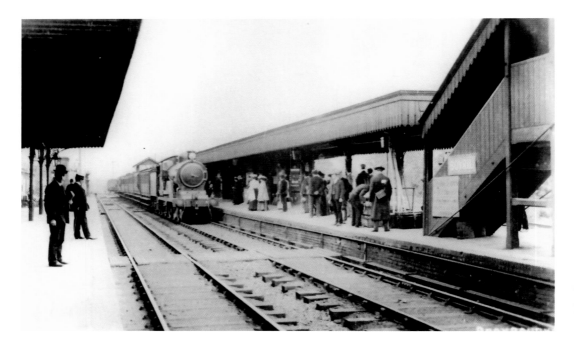

In an older view, a D16-type locomotive arrives on a local service at Broxbourne old station. The platform looks to be fairly busy with passengers. The London-bound platform was an island platform and was connected to the main station building, located at street level, by a footbridge and stairs. (Lens of Sutton Collection)

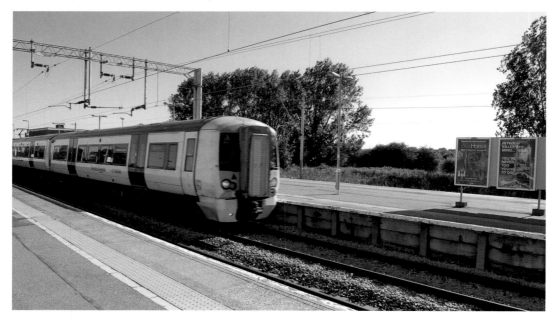

The new station was built around 300 metres north of the old station and has two island platforms. This view is of a Stansted Airport Express service passing through the station at speed. (Andy T. Wallis)

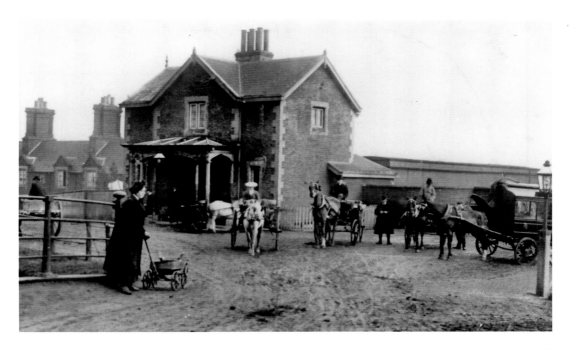

Old Great Eastern photograph of the main station building located at the top of the roadway, with the clearly visible covered footbridge leading across to the stairs and the Up direction platform. The houses on the left survived into the 1970s before being demolished to make way for an extended car park. (Lens of Sutton Collection)

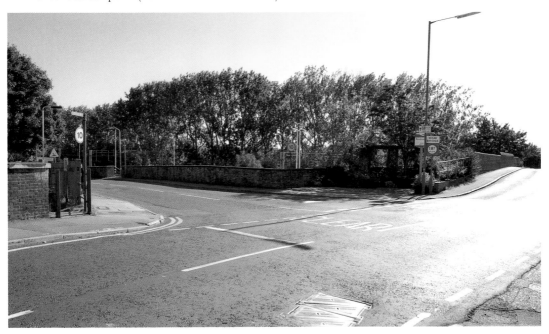

Today nothing remains of the old station building. The road to the present station forms a junction with the Broxbourne to Nazeing Road. (Andy T. Wallis)

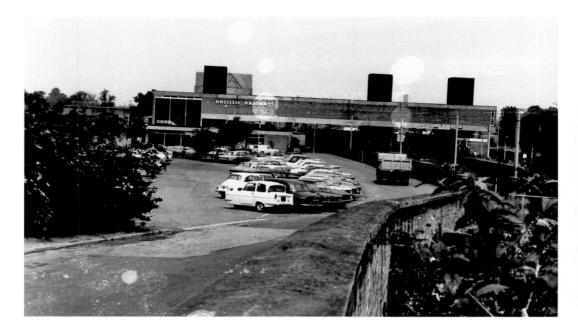

An early 1970s view looking down at the main station buildings from the top of the approach road. Broxbourne was a coal concentration depot during the 1960s and 70s. Supplies were brought in by rail in hopper-type wagons that were unloaded by conveyor system, the wagons being shunted by capstan. (Nick Ellis)

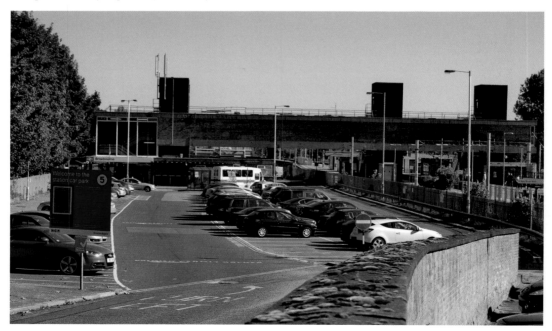

Little seems to have changed since the previous view; the main change is the area now given over to car parking, including the area behind the wall in the top view. The coal depot has closed and is now a two-storey car park. (Andy T. Wallis)

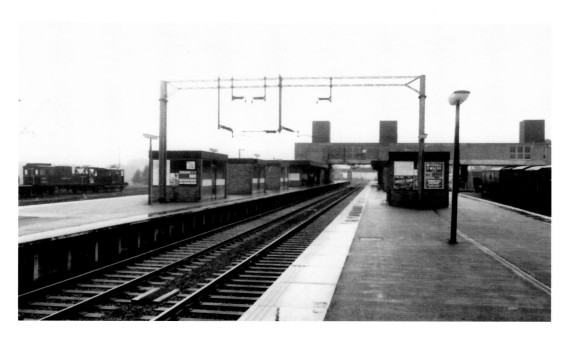

A 1963 view from the country end of the station, looking back at the main buildings. The coal yard was located on the right and several other sidings were located beyond the Up loop line, the furthest line from the platform being the Up goods loop, which saw heavy use in the 1960s and 70s. (Stations UK)

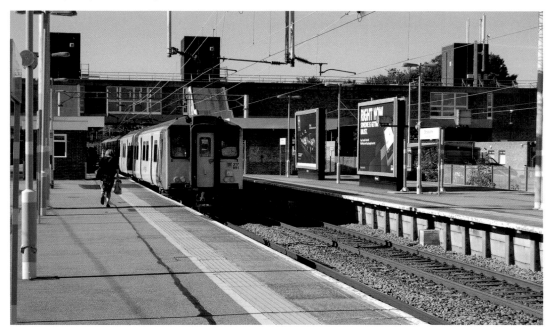

Today, standing on the Up island platform, the station is very busy with trains to Stratford and Liverpool Street. Local services are looped here, for the fast Stansted Express services to overtake, during the daytime, when the line is running at capacity. (Andy T. Wallis)

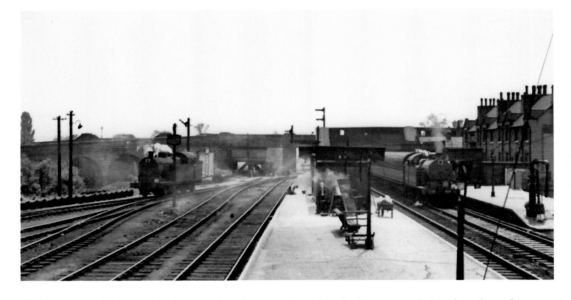

Slightly elevated view, taken from a signal or the signal box looking towards London along the island platform. Two Class N7-type locomotives are featured, with one in the sidings and one on a local passenger train arriving in the Down main platform. This view was taken in 1937. (Stations UK)

Some seventy-five years later, standing at the London end of the Up island platform, the same view is reproduced. The sidings shown in the top view still exist under the weeds on the left of this view. New LED-type signals protect the point work ahead. The bridge in the distance is common in both pictures. (Andy T. Wallis)

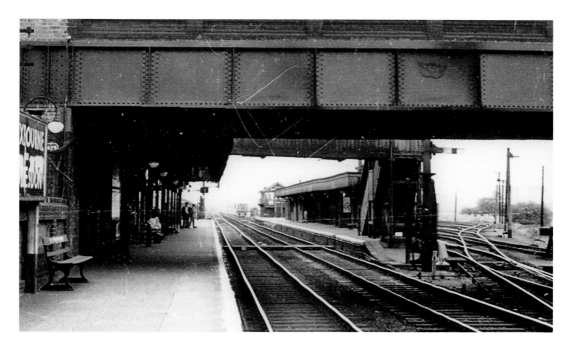

A view looking north from the Down platform, which went under the road bridge as seen on 2 June 1956. The exit from the sidings on the left is still in about the same place today, albeit slightly overgrown. The common feature in both views is the steel girders on the overbridge. (H. C. Casserley)

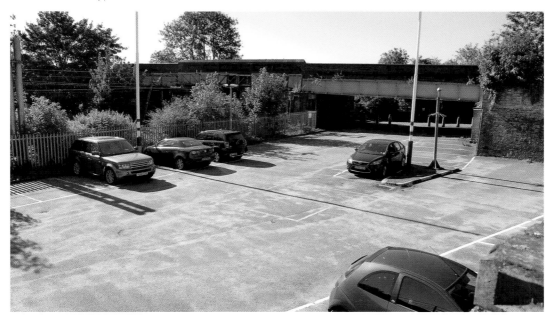

The old station building would have been in the space that is now the car park; a staircase would lead down onto the platform, which continued under the bridge, roughly where the fence is now. The new station is behind the photographer. (Andy T. Wallis)

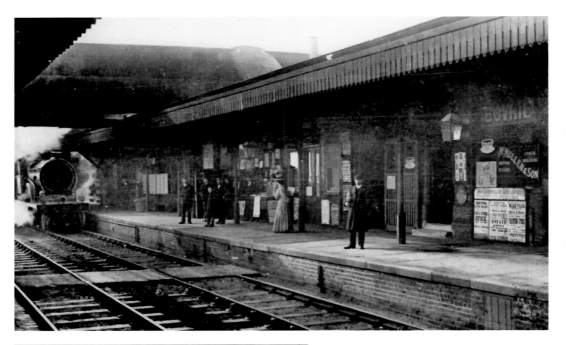

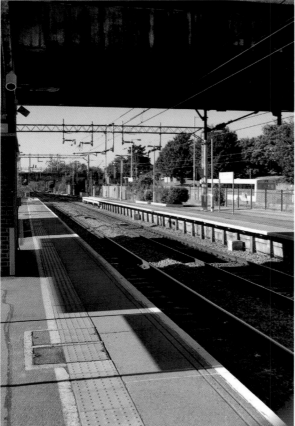

Above: Very old photograph, *c.* 1910, with a Down direction train arriving. The wooden overbridge can be seen crossing the lines to get access to the Up platforms; the platforms were slightly staggered. (Stations UK)

Left: Today, standing on the Up platform and looking back towards the site of the old station by the road overbridge; so much has changed in the 102 years between these two views. (Andy T. Wallis)

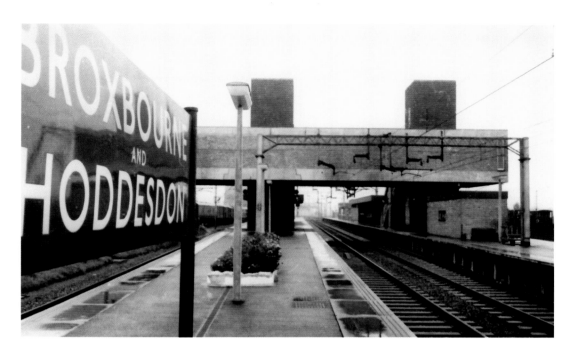

A wet 1963 view featuring the then large, dark-blue enamel station board with the old name of 'Broxbourne and Hoddesdon'. This view is looking towards Harlow and Bishop's Stortford. (Stations UK)

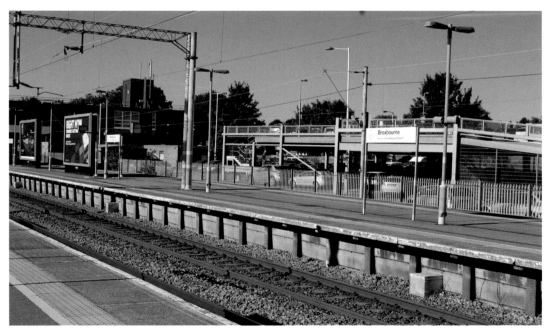

Today 'Hoddesdon' has been dropped from the station name; it is now just Broxbourne, change for Lea Valley Park. The two-storey car park built on the site of the coal depot is seen on the right of this view. (Andy T. Wallis)

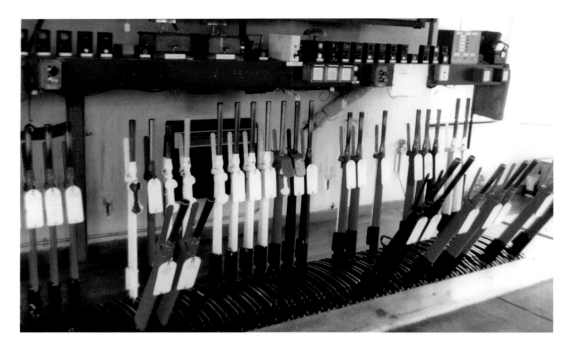

Two interior views of the lever frame in Broxbourne Junction signal box, shortly before it closed when its remaining functions were moved on to Broxbourne Station panel, the adjacent Essex Road level crossing then being worked by CCTV. The signal box was equipped with a Westinghouse type 17A lever frame of some thirty-five levers. By this time there were plenty of spare levers; at one time all thirty-five were working. The old gate wheel had by this time been replaced with lifting barriers. (Andy T. Wallis)

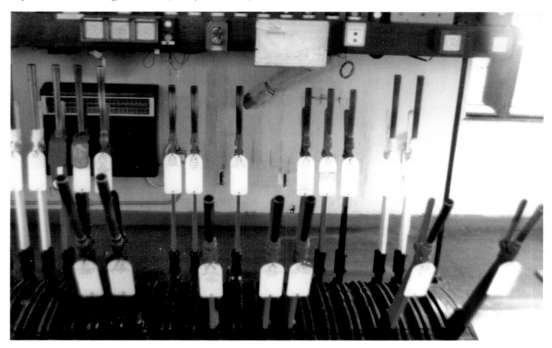

Roydon

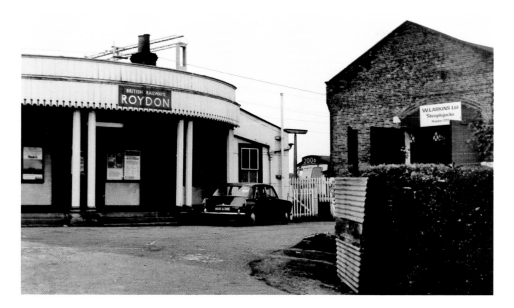

The main station buildings and goods shed at Roydon in the early 1970s. These buildings dated from the opening of the line and now are a listed structure. Your author remembers purchasing his season ticket here for the daily commute to school in 1972! The former goods shed was leased out to a local steeplejack firm. (Nick Ellis)

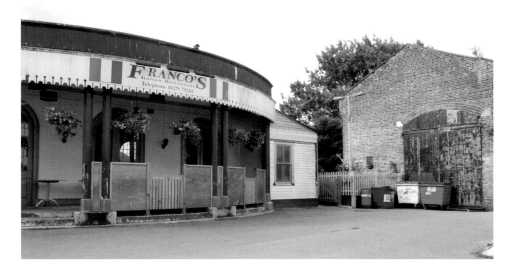

Today the station buildings have been turned into a restaurant, and the original features of the old building have been retained. Unfortunately the goods shed has not fared so well, with the roof partially collapsed and the building looking worse for wear. Fortunately, trains still call here. (Sebastian Sekinger)

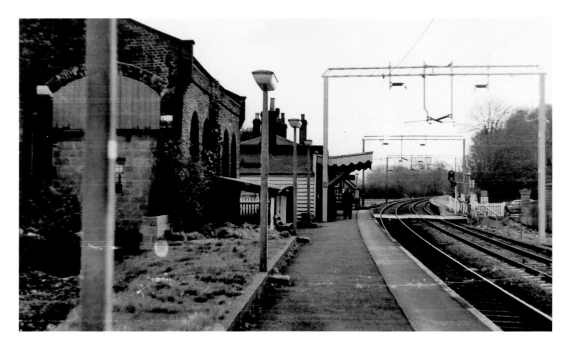

A view along the Down direction platform looking at the main buildings and goods shed in the early 1970s. The platforms were divided by the level crossing, which was at that time controlled from the adjacent signal box. (Nick Ellis)

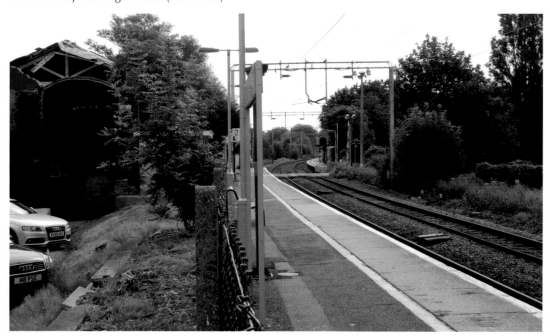

Today the view has changed very little, though the former goods shed has lost part of its end wall. The station has benefited from new platform lighting, and behind the tree a new waiting shelter provides protection from the elements. The former goods yard is now a car park. (Sebastian Sekinger)

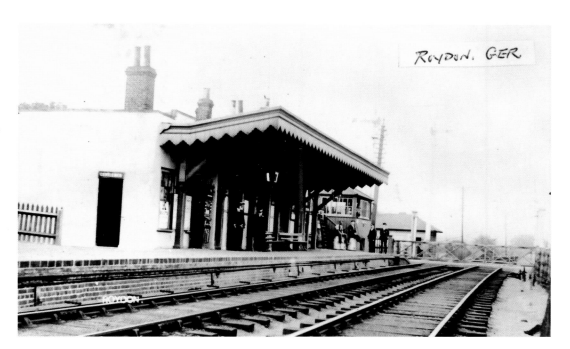

Above: A Great Eastern Railway posed view of the main buildings, seen from the line side with the staff gathered around the signal box and under the station canopy. The canopy was demolished by British Railways in the 1970s; a smaller version was later reinstated after complaints were voiced by the local population, as the building was by then a listed structure. (Lens of Sutton Collection)

Right: Viewed from the other side of the River Stort, looking at the signal box during its last year of operation; the tall lighting column and pole for the future CCTV equipment had already been provided prior to the closure of the signal box. (Dickie Pearce)

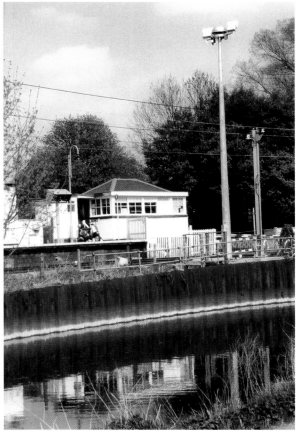

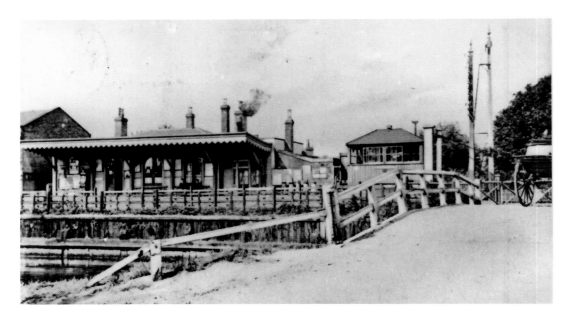

Another very early view of the station and signal box, this time taken from the road leading up to the village. Note the old semaphore signal guarding the level crossing and the original signal box, before it was extended to accommodate a gate wheel and enlarged lever frame. The only protection from falling in the River Stort is a rather rickety-looking fence. (Lens of Sutton Collection)

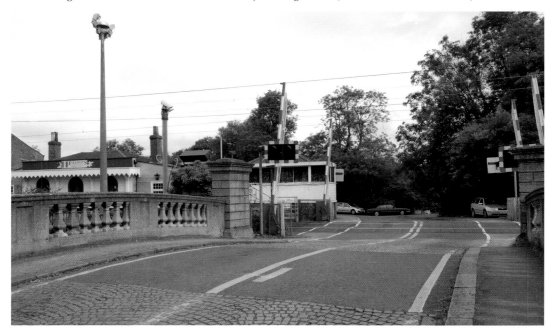

Today the same view shows the modern CCTV-controlled level crossing and boarded-up signal box, with the main station buildings looking very smart as a restaurant. The wooden railings have all been replaced with solid concrete-and-stone parapets. The hump on the bridge is still clearly visible. (Sebastian Sekinger)

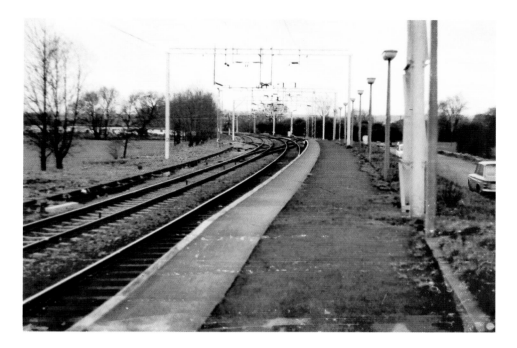

Late 1960s view, looking along the Down platform towards Broxbourne and London. At this time Roydon was equipped with two goods loops at the London end of the station for regulating slow-moving goods trains, all controlled from the twenty-six-lever signal box. (Nick Ellis)

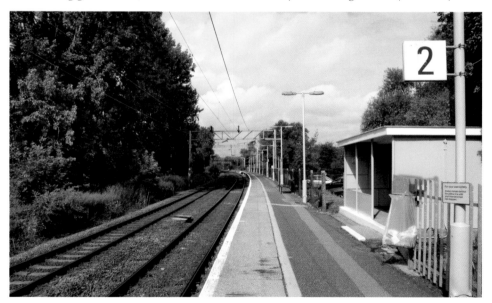

The same view today features new lighting and a modern waiting shelter. All the points and crossovers have been removed, and the platform has gained the yellow line warning passengers to stand behind it when fast trains pass through the platform. On the left, considerable growth has taken place on the trees, planted as a screen for the caravan and camping site. (Sebastian Sekinger)

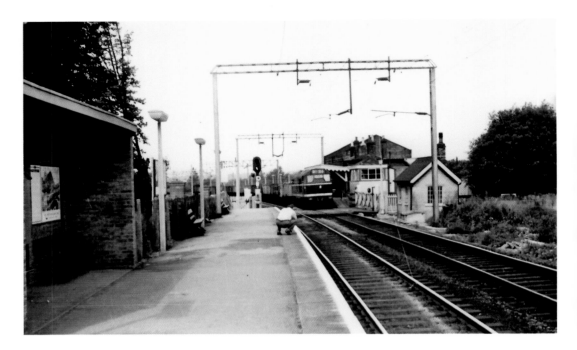

Class 31 diesel hauling a local freight train passes Roydon signal box and level crossing in 1963. The waiting shelter on the left has now been turned into a ticket office, allowing for the ticket office in the main buildings to be closed. The station was boarded up for a while before being let for retail purposes. (Nick Ellis)

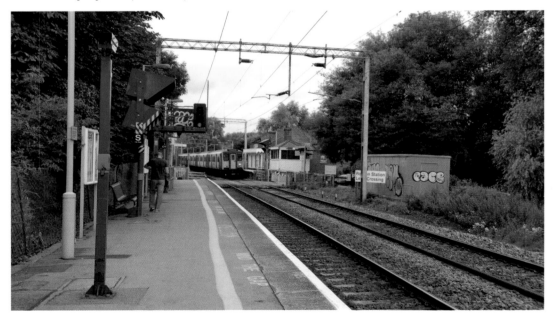

Today, standing in a similar position, a Class 317 EMU is standing in the platform on a local service to Bishop's Stortford. The small building on the right has been demolished and replaced with a signalling equipment building. (Sebastian Sekinger)

Burnt Mill (Later Harlow Town)

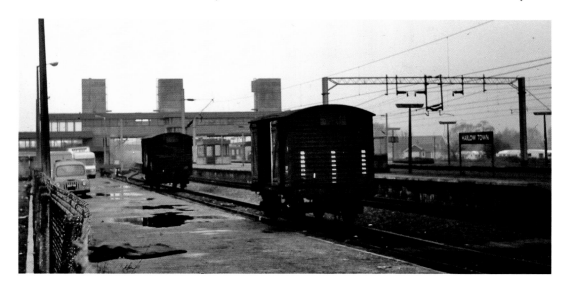

An early 1970s view, taken from the car park of the Up siding at Harlow Town, with a pair of enclosed vans waiting to be picked up. In the 1970s and early 1980s a collection-and-delivery parcel service was operated from Harlow Town; previously this had been based at Harlow Mill. (Nick Ellis)

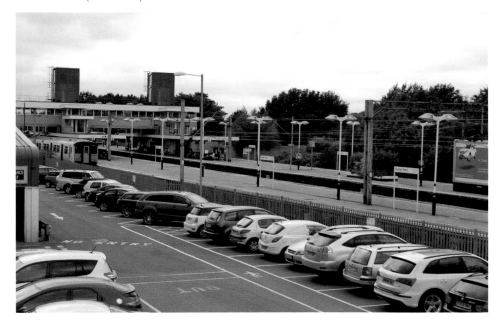

Today the Up siding has gone under the tarmac for an extended car park, from which this elevated view was taken. Traffic had increased so much that a three-storey car park had to be built to cope with the demand caused by commuters. (Andy T. Wallis)

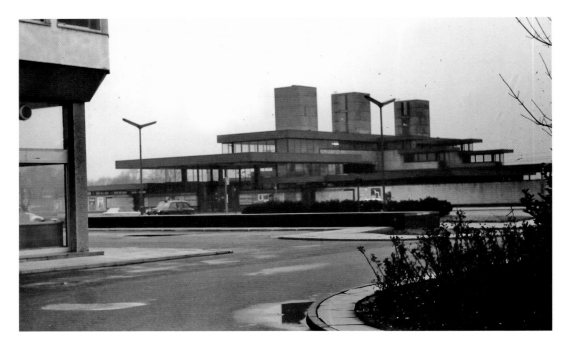

External view of Harlow Town station, taken from the adjacent car park for the building on the left, which at that time was used by Longman's Publishing. The new station was built on the site of the former Burnt Mill station, the level crossing being replaced with an overbridge just to the south of the station. (Nick Ellis)

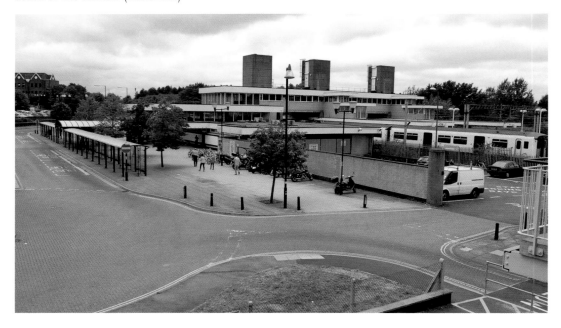

Using the height of the multi-storey car park, the view today shows the station buildings, which had a major refurbishment in 2010 at the fiftieth anniversary of the original opening of the station. The office block out of view has also been replaced with flats and retail units. (Andy T. Wallis)

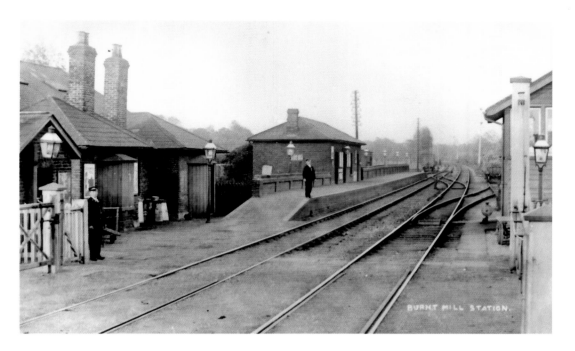

A very early view of Burnt Mill station and level crossing, looking towards Bishop's Stortford and Cambridge. When the rebuilding of the station commenced to create the new Harlow Town station, a new overbridge was provided to allow the level crossing to close. The old signal box ended up being at one end of the new Up island platform; a small gap in the platform works was left unfinished until the old box closed. (Lens of Sutton Collection)

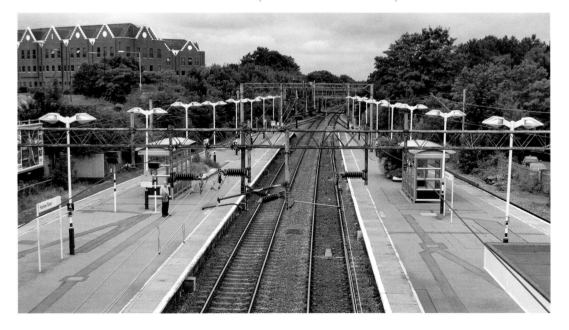

The view today is from the station overbridge, looking towards Broxbourne. The old level crossing was roughly where the platform waiting shelters are located. (Andy T. Wallis)

31

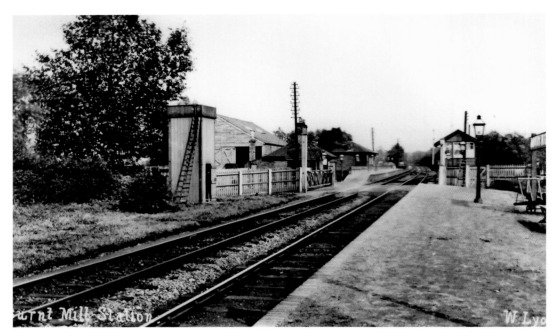

Above: An early view of Burnt Mill station looking towards Bishop's Stortford; note the old water tower and oil lamps on the platforms. (Lens of Sutton Collection)

Left: The old station has been swept away and a new four-platform example has been provided for the new town. A modern Class 379 EMU departs from the Down platform. (Andy T. Wallis)

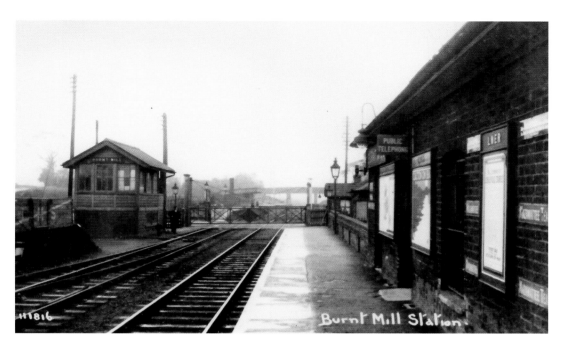

Above: A London & North Eastern Railway (LNER) view of the old station, this time looking towards Broxbourne and London. The signal box contained a Saxby & Farmer lever frame to control the level crossing gates, signals and sidings at the station. (Lens of Sutton Collection)

Right: Standing at the London end of the Down island platform, a modern Class 379 EMU arrives on a semi-fast Stansted Express service. (Andy T. Wallis)

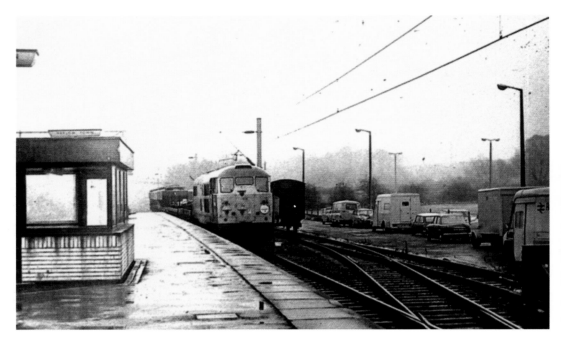

Above: A Class 31 diesel hauls a short freight train into the Up loop at Harlow in the early 1970s; the hoppers probably originated from a local glass works where they had a private siding connected to Harlow Mill yard. (Nick Ellis)

Left: No diesels today as there are very few spare pathways during the daytime due to the fifteen-minute-interval airport service. A Class 379 EMU is seen arriving in the Up platform with a local service to London Liverpool Street. (Andy T. Wallis)

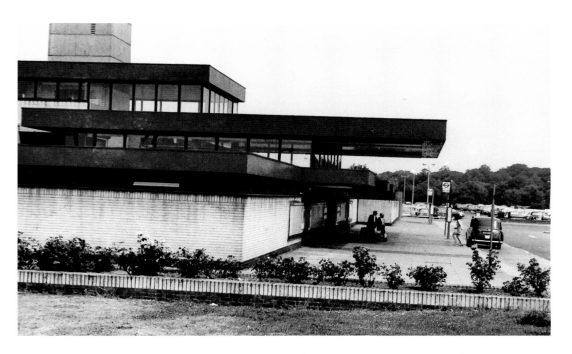

Exterior view of Harlow Town station, taken in the early 1970s. In those days the buses stopped outside the station, with the taxi rank being on the other side of the road island; the grass was kept neatly cut. (Nick Ellis)

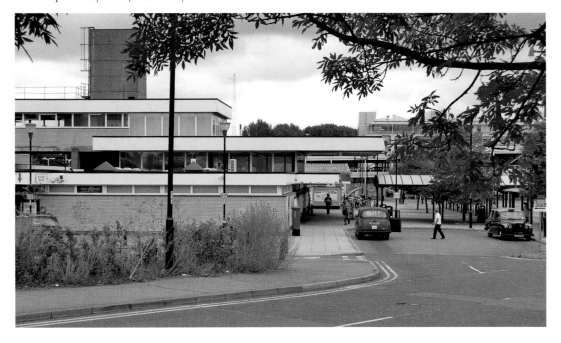

Some forty years later the road layout has changed, with a dedicated taxi waiting area, along with a wider paved area leading to the bus stops and a service road on the far right. The station was fully refurbished in the 1990s; the former grassed area has been left to nature. (Andy T. Wallis)

A pre-1923 view of the old Burnt Mill station looking towards the level crossing; the house on the extreme left still stands today, although completely surrounded by new tree growth. (Lens of Sutton Collection)

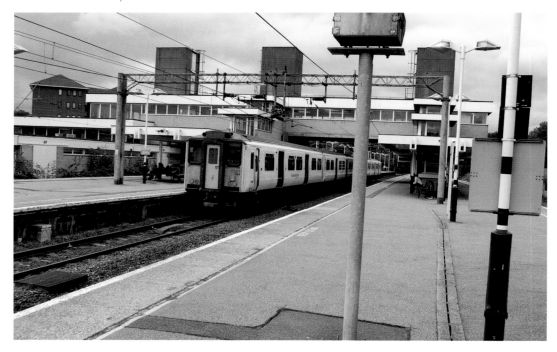

Looking the opposite way, today a Class 317 EMU stands in the Up main platform awaiting departure to London. (Andy T. Wallis)

Harlow (Later Harlow Mill)

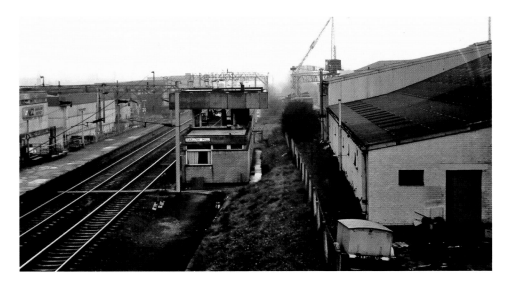

View from the road overbridge, taken in the early 1970s and showing Harlow Mill signal box and the Up direction platform. At this time National Carriers Ltd occupied a large building adjacent to the railway; by the mid-1980s this had all gone. The yard was then used as a stone terminal, a purpose-built depot being built later on the site of the old NCL depot. (Nick Ellis)

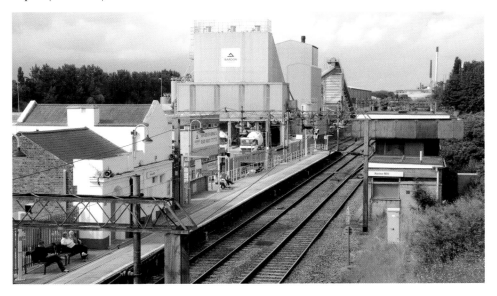

Today the signal box is closed and boarded up; all the signalling is now controlled from Liverpool Street IECC. The other main change is the purpose-built aggregates depot dominating the skyline. Before this depot was built, aggregate traffic was handled at both Harlow Mill and Bishop's Stortford. (Sebastian Sekinger)

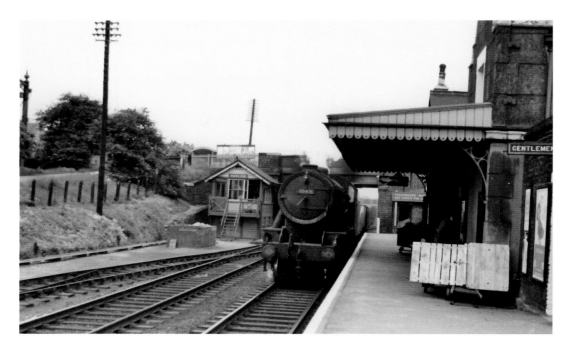

WD 2-8-0 90431 hauls a goods train through the station during the 1950s. The road overbridge had been rebuilt by this time, with the old Harlow signal box hard up against it. The points from the Down goods loop can be seen merging on the left. (Roy Edgar Vincent/Transport Treasury)

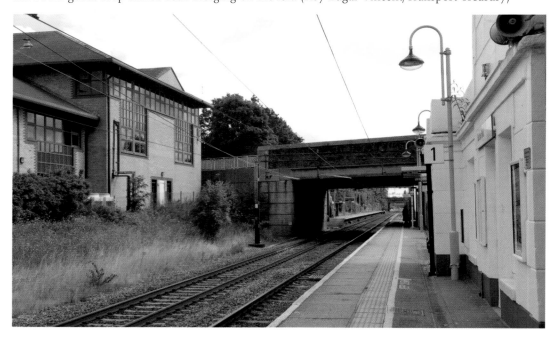

Today the view has changed somewhat, with the signal box gone and the station losing its canopy. In the intervening years an industrial unit has been built adjacent to the railway. (Sebastian Sekinger)

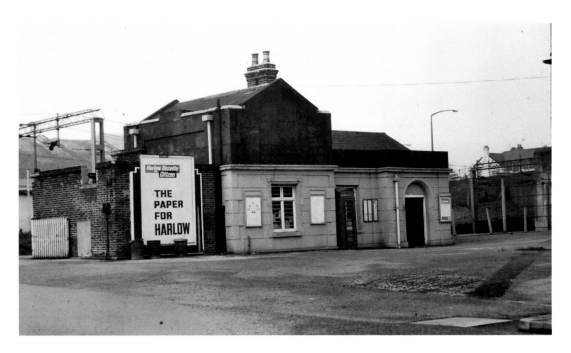

An early 1970s view of the station buildings after the station house had been demolished. The red telephone box would survive a few more years before being replaced. The only staff nowadays is a booking clerk on an early shift from Monday to Saturday, a far cry from when the station had porters, signalmen and a stationmaster. (Nick Ellis)

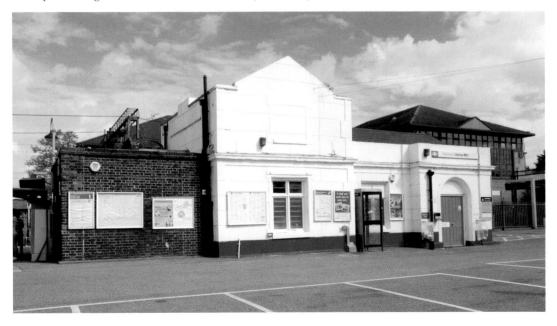

Today a new coat of paint and different noticeboards seem to be the only changes. The booking office is only open during the mornings; a ticket-issuing machine has been installed by the entrance gate on the left. (Sebastian Sekinger)

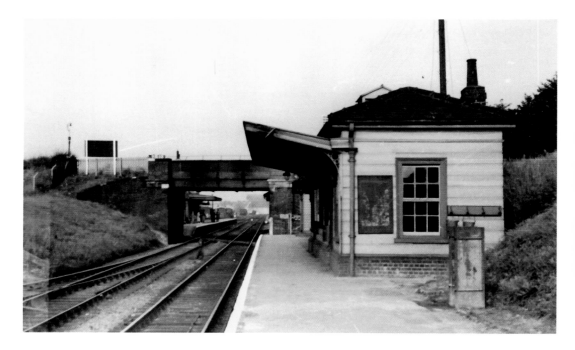

A view taken from the Down platform looking back through the main road overbridge in the late 1950s. Before work commenced on electrification of the line, the road overbridge was rebuilt and the siding on the left shortened to allow for a platform extension and the provision of a footbridge. (Stations UK)

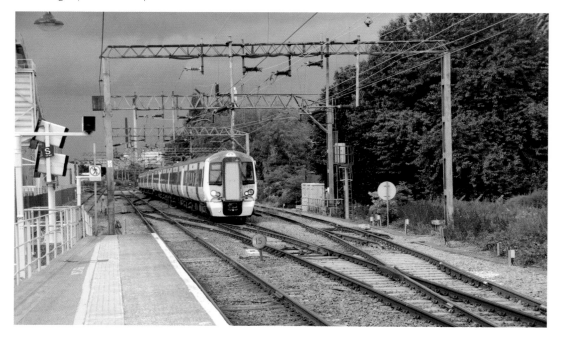

A contrasting view, with rain threatening as a modern Class 379 EMU races through the station on a non-stopping service. (Sebastian Sekinger)

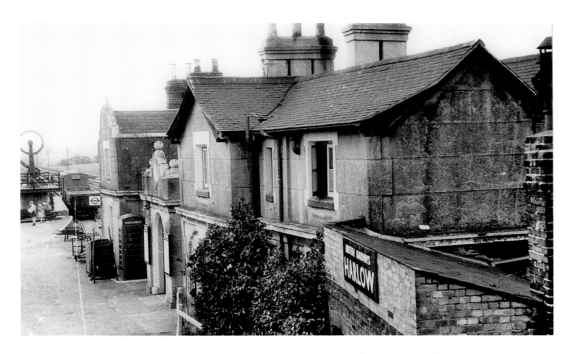

Taken from the then A11 overbridge looking down onto the station buildings on 2 June 1956, showing the original stationmaster's house and station buildings, proudly displaying the original 'British Railways Harlow' enamel dark-blue sign on the wall. (H. C. Casserley)

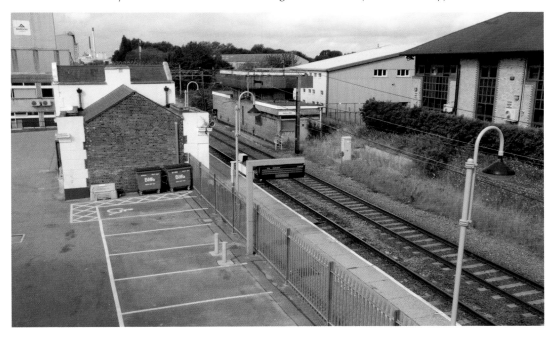

Today, a near-identical view of the surviving buildings and boarded-up, late 1950s-built signal box. The site of the old station house has now been levelled and turned into additional parking. (Sebastian Sekinger)

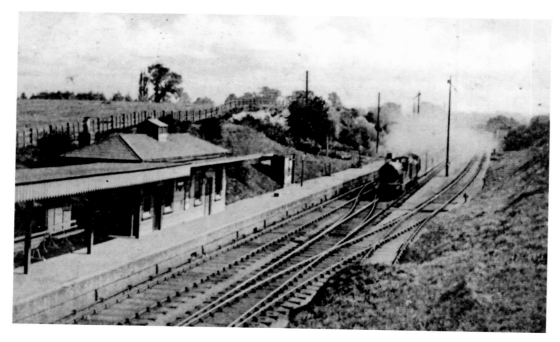

A very old, elevated view from the road overbridge of the old station as a train passes through. Note the very tall lower quadrant semaphore signals and the old buildings; these survived into the 1960s. (Lens of Sutton Collection)

The old buildings have all been swept away today, being replaced with a covered waiting shelter. On both sides of the railway, behind the trees, houses have been built. (Sebastian Sekinger)

Sawbridgeworth

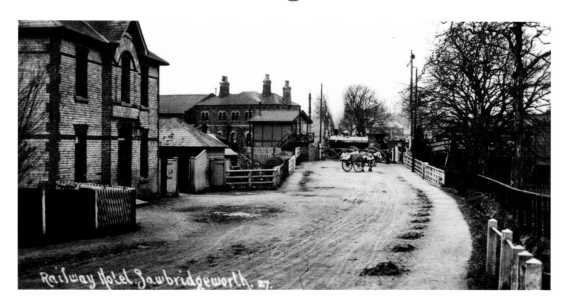

An old postcard showing the railway hotel, signal box and station level crossing at Sawbridgeworth, with a locomotive departing towards Harlow and London. The road surface seems well rutted with carriage wheels. Note the tall semaphore signal protecting the level crossing. (CVRPS Ltd Collection)

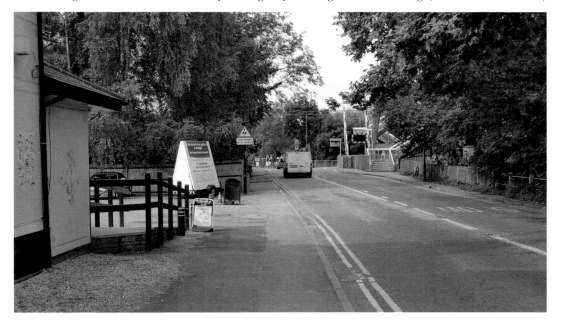

Today the railway hotel still exists, the maltings have all been converted into flats or retail units and the level crossing is now controlled by CCTV from Liverpool Street. Considerable tree growth has taken place on both sides of the road in the intervening years. (Andy T. Wallis)

A Class J17 locomotive is seen shunting the yard at Sawbridgeworth during the late 1950s. This view was taken from the station footbridge adjacent to the level crossing. (D. Lawrence/Photos from the Fifties)

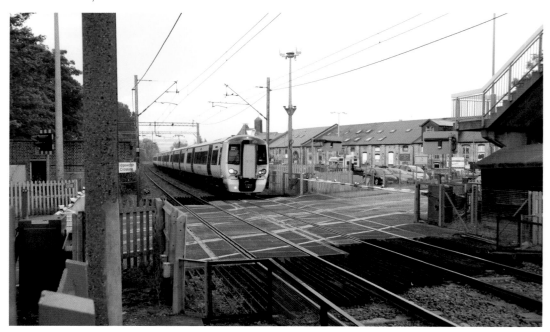

A similar view today, taken from underneath the footbridge as a Class 379 races through the station, having passed the former goods yard, which is now all given over to retail units and car parking. (Sebastian Sekinger)

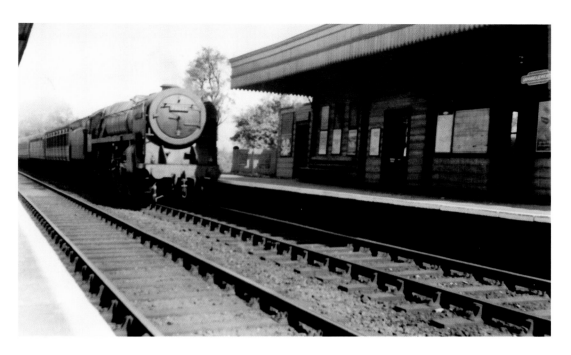

Taken from the level crossing adjacent to the platform ramp, Class 7P 70034 powers through the station on an Up express passenger service; with a line speed of 80 mph, these locomotives made easy work on this line. (D. Lawrence/Photos from the Fifties)

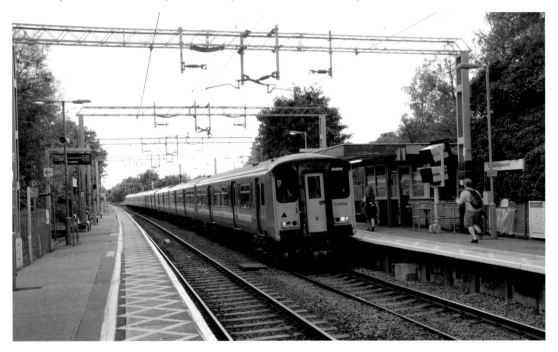

Stalwart EMU Class 317664 and another unidentified unit of the same class arrive on a Stratford local service during the Olympic Games. (Sebastian Sekinger)

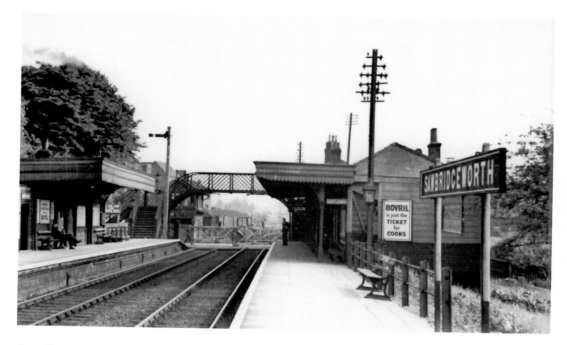

Overall view of the station as seen in 1937, with the tall platform starting signal now replaced in concrete by the LNER; note the Bovril advert on the station building wall. (Stations UK)

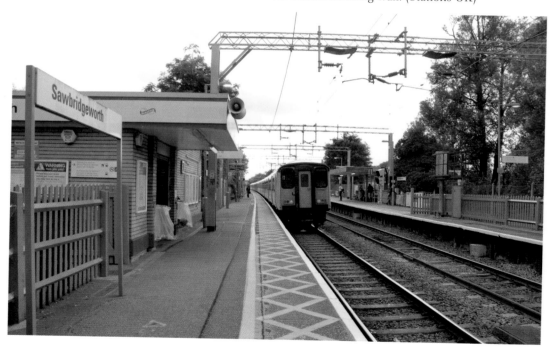

Today, the new-style 'Sawbridgeworth' station name board can be compared to the earlier example as this view looks towards Bishop's Stortford, with a local train departing. All the old buildings have long since been replaced with modern, functional ones. (Sebastian Sekinger)

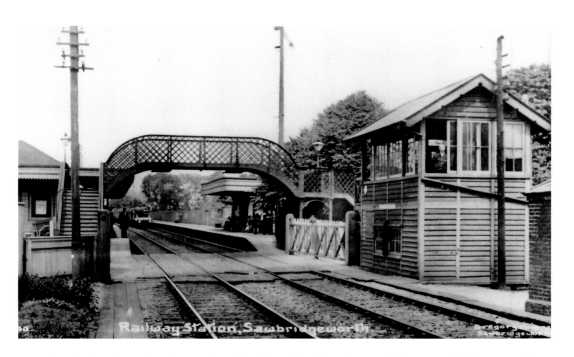

Posed view featuring the station, signal box, level crossing and the very tall lower quadrant starting signal. The date is around 1923. The station had gained a footbridge when compared to the view on page 49. (Lens of Sutton Collection)

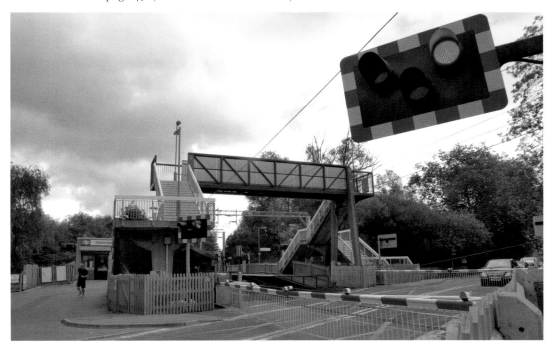

Today the station has been modernised, with new buildings and footbridge and with the level crossing being worked by CCTV from Liverpool Street. (Sebastian Sekinger)

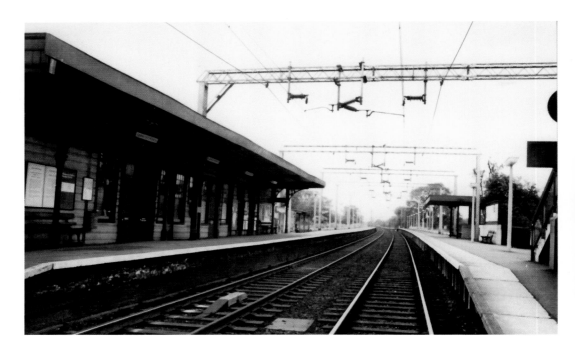

1963 view, post-electrification. The original station buildings on the Down platform are still in use, while on the Up platform a more modern waiting shelter has been provided. This view is looking towards Bishop's Stortford. (Stations UK)

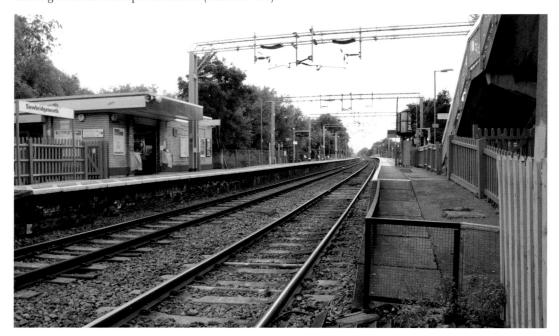

Today, standing on the edge of the level crossing, the same view shows the new buildings – provided some years ago – on the Down platform. Very little else has changed, except for the platform extensions at the far end of the platforms. (Sebastian Sekinger)

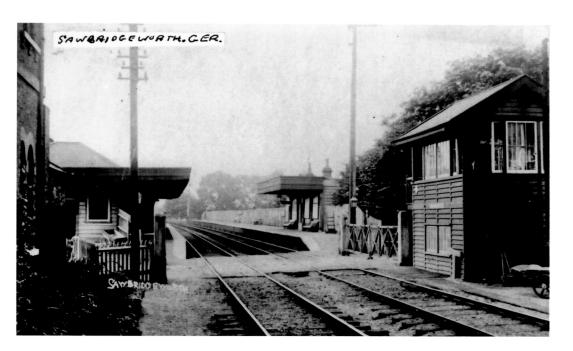

A very early Great Eastern Railway view of the station before the footbridge was provided. This view, taken from the line side, was with the gates closed to road traffic. There is no sign of any passengers, a far cry from today. (Lens of Sutton Collection)

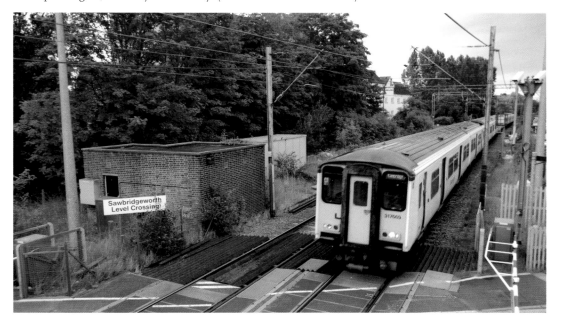

Unable to get line-side today, a slightly different view from the footbridge shows a Class 317 EMU passing over the level crossing, the old signal box stood on the left where the Sawbridgeworth level crossing sign is now located. The brick building is a relay room for signalling equipment. (Sebastian Sekinger)

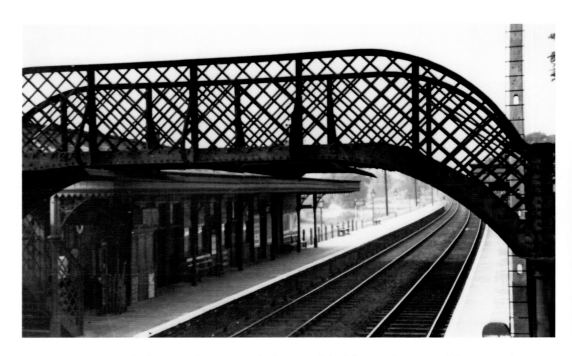

A 1937 LNER view looking at the Down platform and buildings; the original lattice girder footbridge allows for good views of approaching trains. The platforms here were their original length; they have been extended twice since those days. (Stations UK)

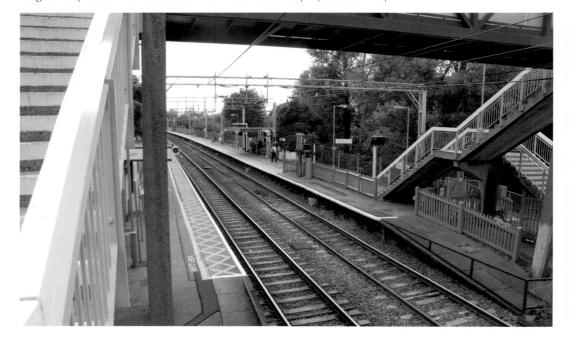

A similar view today, looking from the new footbridge at the Up direction platform and waiting shelter. Prior to electrification the footbridge was replaced, and has since received a new span as the original concrete example was beginning to crumble and fall to bits. (Sebastian Sekinger)

Spelbrook

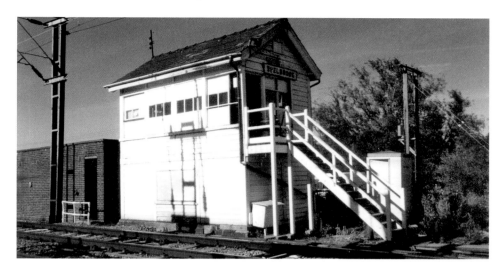

Spelbrook signal box, standing guard over the level crossing, contained a McKenzie & Holland 4-inch-centre twenty-four-lever frame with all the levers working during the 1950s. After the 1960 resignalling this was reduced to twenty working levers; further reductions would follow as the layout was rationalised, with the removal of the goods loops and crossovers. (Dickie Pearce)

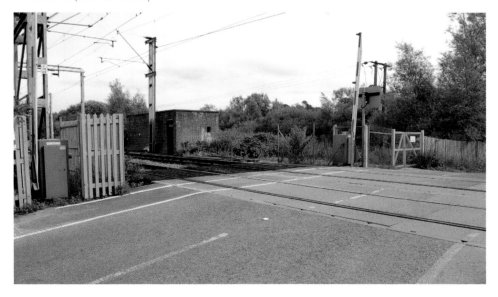

Today the signal box has been demolished, the crossing widened – it is now controlled from Liverpool Street by CCTV – and the old brick relay room still stands. The top half of the signal box was saved and removed to Mangapps Farm Railway Museum, after which it was moved to Ongar for restoration as a working signal box on the new Epping and Ongar Railway. (Andy T. Wallis)

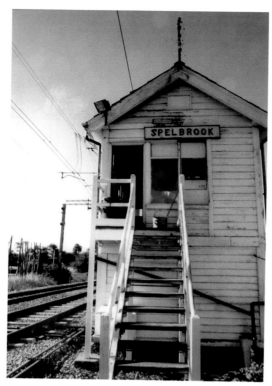

Close-up view of Spelbrook signal box; the Railway always spelled the name incorrectly, missing off one 'l'. This was eventually rectified with the latest resignalling of the route at the turn of the century. (Dickie Pearce)

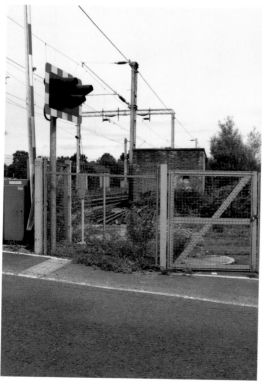

Today, the signal box has gone and a strong pair of security gates protect the vacated site. The old box was hard up against the railway, with the relay room adjacent to it. One of the level crossing booms and a road signal can be seen in this view. (Andy T. Wallis)

Bishop's Stortford

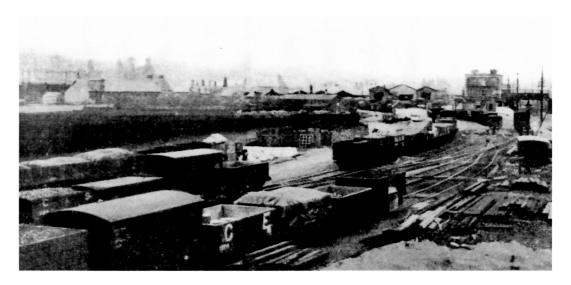

Pre-1923 photograph of the station and goods yard with plenty of wagons present. Many years later there was a coal concentration depot in the yard, and later still stone traffic was handled here. Now there is no regular traffic. (Lens of Sutton Collection)

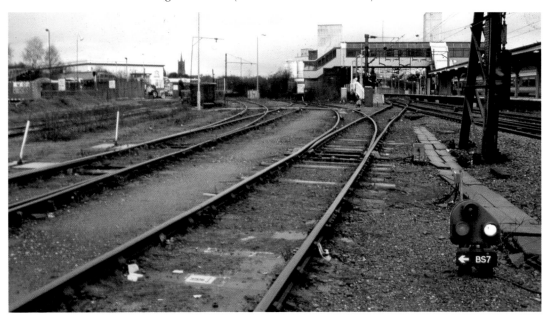

In later years there was only one connection into the yard, running from the Down platform. The coal depot was on the left of this view; after the coal depot closed, the unloading facilities were used by stone trains for a number of years before this traffic moved to the purpose-built depot at Harlow Mill. (Mick Barnes)

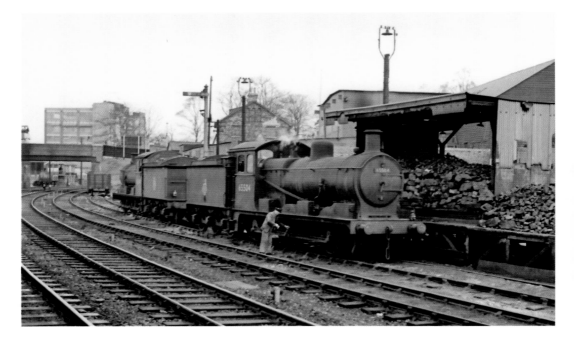

Class J17 locomotives 65504 and 65545 on shed being serviced, as seen on 28 April 1956. A small turntable was provided, as well as coaling and watering facilities. The signal seen above the rearmost locomotive is the branch starting signal. (Brian Connell/Photos from the Fifties)

Today all has gone, including the branch to Dunmow. All the spare railway land was sold off and for many years was used as a garage workshop and showroom. This too has now gone, and the land awaits its next use. The bridge seen in the top view is the bridge on the extreme left of this view. (Andy T. Wallis)

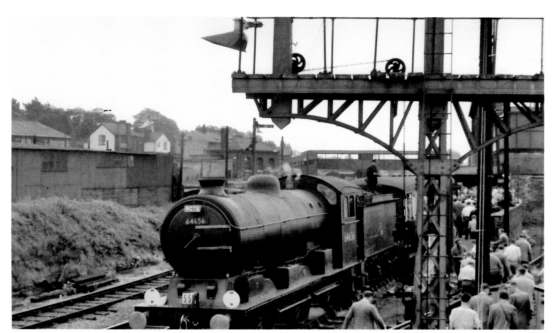

Above: Class J19 locomotive 64656 stands at the country end of Bishop's Stortford Down platform, waiting to depart with an RCTS Special on 10 August 1958, which was booked to travel via the Dunmow branch. The large signal in the foreground would survive a couple more years before the station was resignalled. (David Lawrence/Photos from the Fifties)

Right: Today, with the platform now extended under the road bridge, a similar view can be obtained from the road overbridge. The signal in the previous view was roughly where the overhead gantry now stands. (Andy T. Wallis)

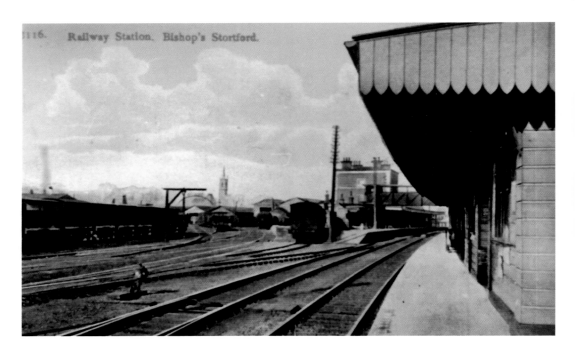

An early view of the station, taken from the Up island platform looking towards the Down platform and goods yard, which seems to have plenty of traffic in it. (Lens of Sutton Collection)

Today, standing on the station footbridge and looking the opposite way, the goods yard can be seen, completely overgrown with weeds. There is now no regular traffic to the goods yard. (Andy T. Wallis)

Two views taken from the signal box doorway feature a short engineers train hauled by a Class 37 diesel, just about to pass the box, travelling towards Cambridge or March. This view was taken in the mid-1990s. (Andy T. Wallis)

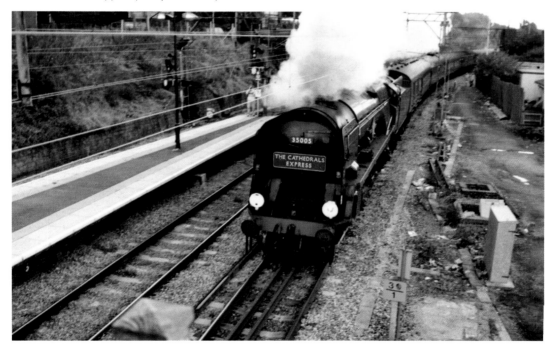

Locomotive 35005 hauling *The Cathedrals Express* powers through the station at 50 mph on a special working during the 1990s. (Mick Barnes)

General view of the station taken from the Down platform in 1963, with a Class 31 diesel standing with a train in the Up platform. The remains of the locomotive stabling point and connections to the old turntable can be seen. (Stations UK)

A Sunday view of the station taken from the Down platform; on this occasion there was engineering work taking place on the line, and the unit in platform 3 was stabled. The airport services were using platform 2, and those connecting with bus services were using platform 1. (Andy T. Wallis)

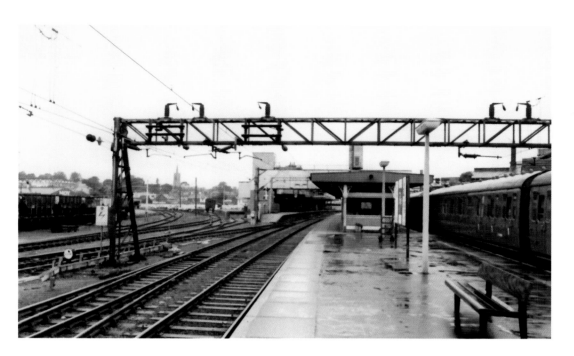

A 1968 view of the station looking towards Cambridge; an example of the first generation of EMUs can be seen in the back platform. Most local services were provided by Class 305 5XX units, of which there were nineteen available as four-car units for working the service to London. There seems to be plenty of traffic in the goods yard. (Stations UK)

Standing at the London end of the Down platform looking at the new signal, which routed trains back to the Up main or Up passenger loop via the crossover at the end of the platform, an Up Stansted Express service is seen departing from platform 2. (Andy T. Wallis)

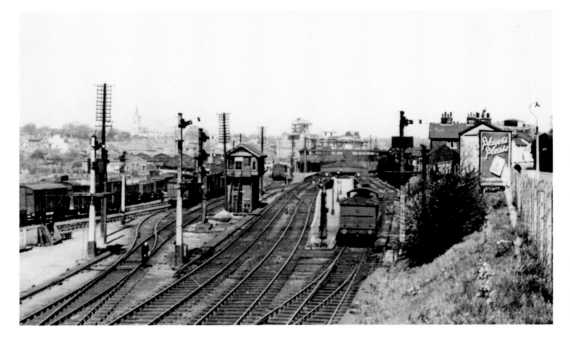

A 1950s view of Bishop's Stortford, taken from the main A11 overbridge looking north at the station and signal box. This is pre-modernisation, with the station controlled by semaphore signals from two signal boxes. Bishop's Stortford South was equipped with a sixty-five-lever frame. (Stations UK)

Unable to replicate the previous view due to raised bridge parapets and vegetation growth, this view is looking down on the station and very overgrown goods yard. The train is stabled in platform 3. (Andy T. Wallis)

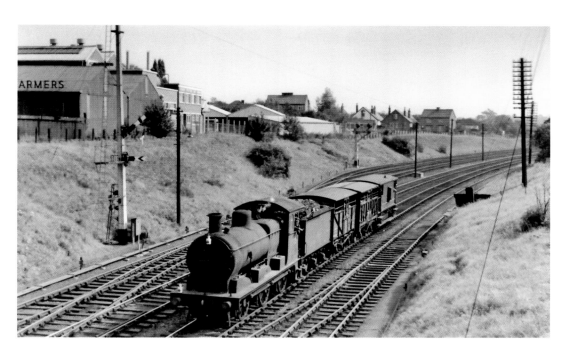

A very short freight train, featuring two livestock wagons and a brake van, is seen approaching the station on 8 September 1956, the milk depot on the top right supplied milk to the surrounding area; it was later taken over by Unigate, only to close in the 1980s. (R. C. Riley/ Transport Treasury)

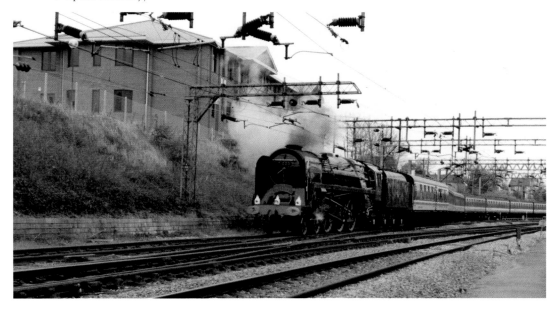

At track level but in a similar place, we see 8P 71000 *Duke of Gloucester* departing from the carriage sidings with stock for a steam special on the weekend of 18/19 April 1993. The dairy has gone and is now a block of flats; the Down siding, bottom right, has also been lifted in this view. (Mick Barnes)

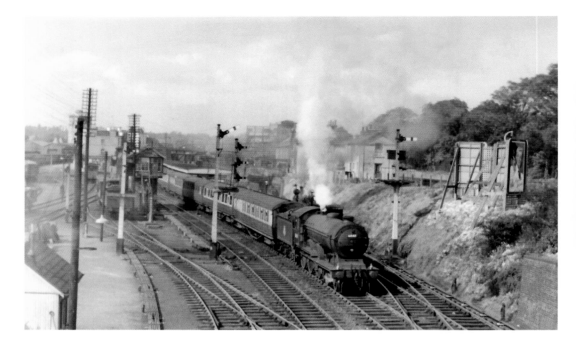

Locomotive B12 61547 departs with a London-bound train from the station on 8 September 1956. Note the Up starting signal located on the wrong side for the Up main line; all these old semaphores were swept away in 1960, when new signalling was introduced in conjunction with electrification. (R. C. Riley/Transport Treasury)

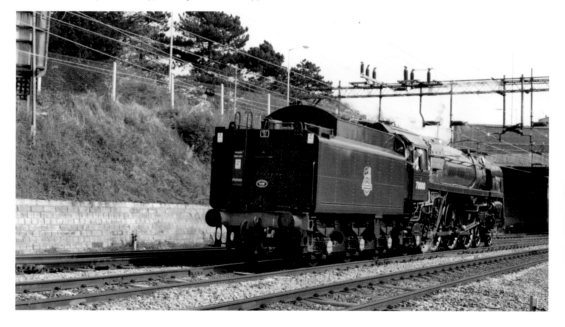

During a steam weekend in April 1993, Class 7P *Britannia* is seen running light engine at the London end of the station. The locomotives were turned at Stansted Airport triangle after they had arrived at Bishop's Stortford, ready for their next departure northwards. (Mick Barnes)

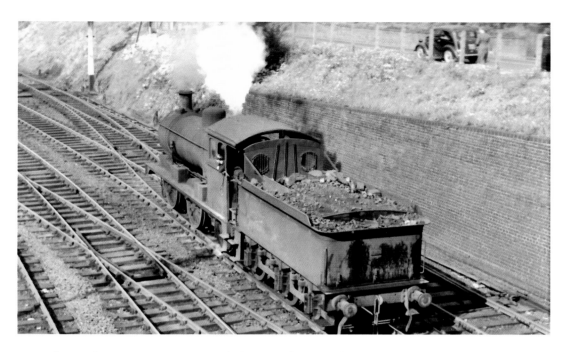

Class J17 locomotive 65508 running light engine between the platforms. The quality of the coal in the tender looks to be very varied, from some large lumps to dust! (R. C. Riley/Transport Treasury)

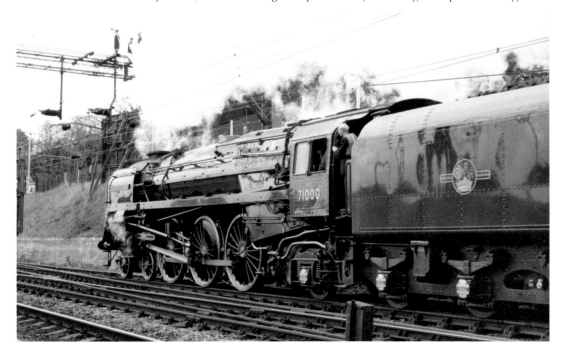

April 1993, as locomotive Class 8P 71000 *Duke of Gloucester* hauls stock out of the sidings into the station for the next working. The steam specials had to fit into the booked passenger service on the line. (Mick Barnes)

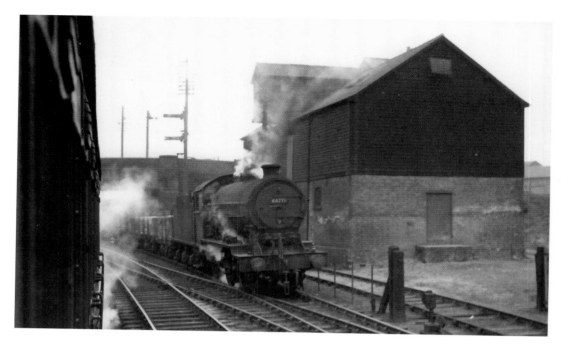

Seen from the carriage window of a Braintree to Bishop's Stortford local passenger train, locomotive 64771 is seen on the Down main line just to the north of the station; the granary on the right received regular traffic by rail. (Transport Treasury)

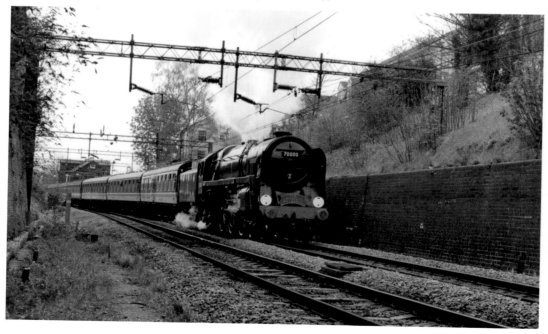

Taken in 1993 from the trackbed of the Dunmow branch, locomotive Class 7P 70000 *Britannia* departs towards Cambridge on a steam special. The granary building in the background has now been converted to flats. (Mick Barnes)

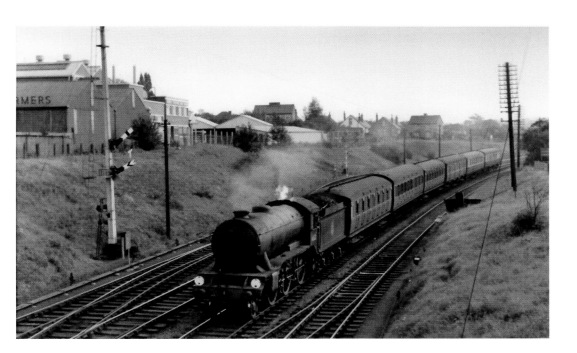

Locomotive 61822 is seen approaching the station in September 1956 with a six-coach train for Cambridge. The signal on the left is Bishop's Stortford South's Down home signal, with the north distant underneath it indicating a clear road through the station. (R. C. Riley/Transport Treasury)

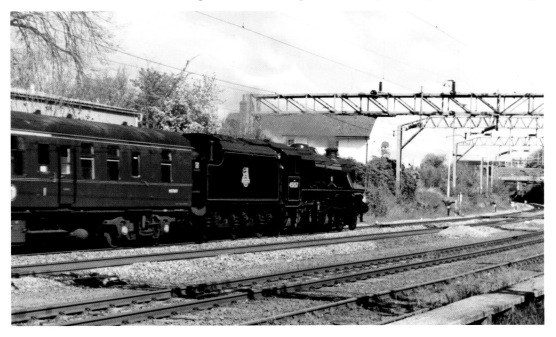

A 1990s view of an unidentified Black Five, hauling a steam special, passing the carriage sidings at the south end of the station. The lines in the foreground were the Up main, Up passenger loop and Up loop next to the walkway. (Mick Barnes)

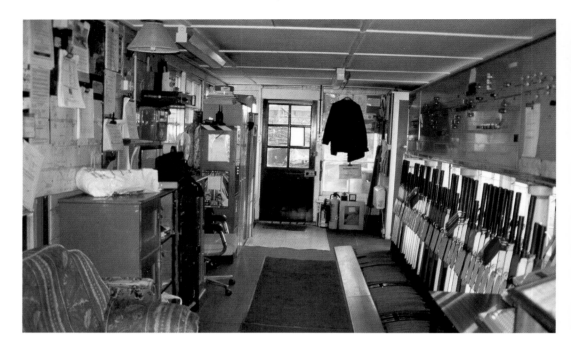

Two interior views of Bishop's Stortford South signal box taken in the late 1990s. The first is looking towards the door; the frame and panel are on the right. The panel was extended in the early 1990s to control the new Stansted Airport branch. The bottom view is in the opposite direction, there are plenty of (spare) white levers now in the frame, which had been shortened in 1960 by twenty levers when the station was resignalled with colour light signals. (Mick Barnes)

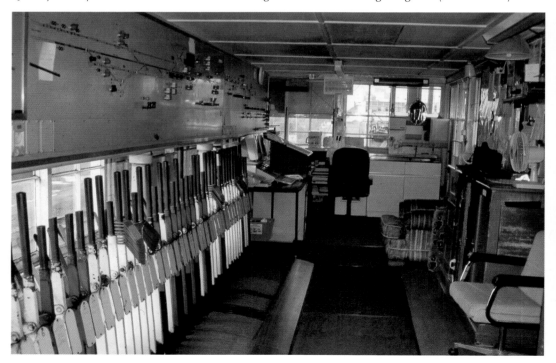

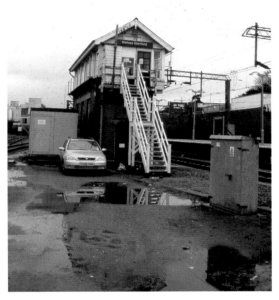

Right: Two views of Bishop's Stortford South signal box, originally built by the LNER in the 1930s and equipped with a sixty-five-lever frame; this was reduced in the 1960s resignalling to forty-five levers when a panel was added to work the new colour light signals and all the signalling at the north end of the station, allowing for the north box to close. (Mick Barnes)

Below: Today the signal box is closed and boarded up awaiting its fate; all the signalling on the line is now controlled from Liverpool Street. (Andy T. Wallis)

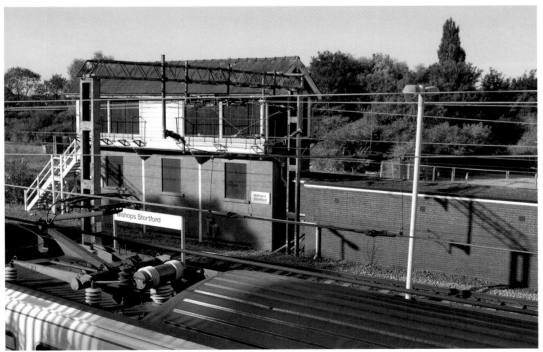

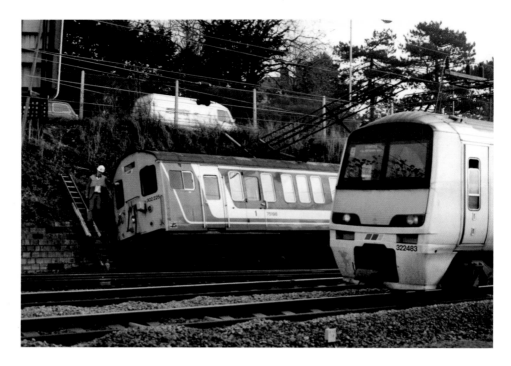

Just had to include these two views of EMU Class 302225, which came to grief on the trap points protecting the back platform from the carriage sidings. The accident happened due to miscommunication between the signalman and driver; unfortunately an overhead mast was demolished in the incident. Services were restored to the main lines soon after, as can be seen with unit 322483 passing the site a few hours later. The lower picture shows the unit derailed, with the overhead stanchion leaning on top of the coach. (Mick Barnes)

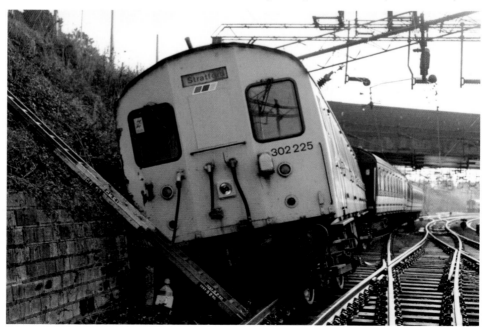

Stansted Mountfitchet

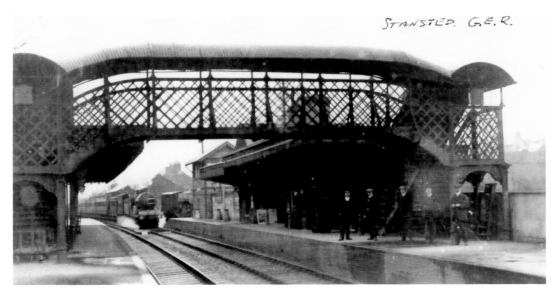

STANSTED. G.E.R.

Above: An old Great Eastern Railway posed view featuring the staff, with a train arriving in the Down platform. In this view are the signal box and the old lattice steel girder footbridge with the corrugated sheet-type roof to protect the passengers from the weather. (Lens of Sutton Collection)

Right: Unable to get the exact position, this view is through the rebuilt overbridge looking at the station buildings. With electrification north of Bishop's Stortford, all the overbridges had to be rebuilt or modified to give clearance to the overhead live wires. (Andy T. Wallis)

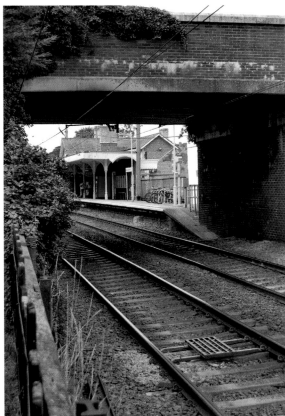

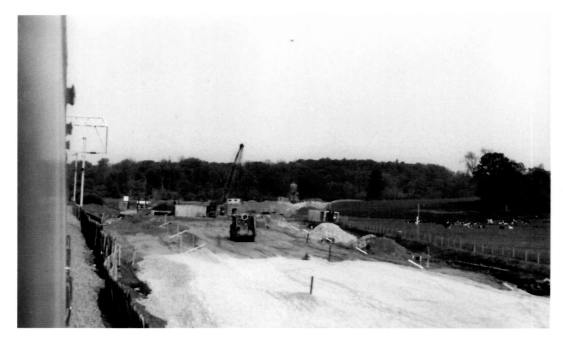

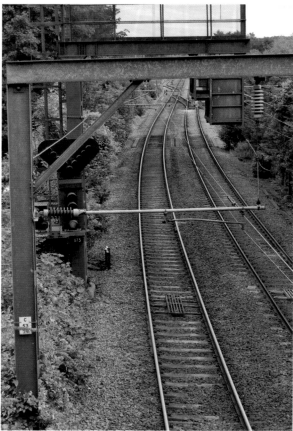

Above: Stansted South Junction under construction as part of the new rail link to Stansted Airport. There were to be two junctions; one facing London and the other facing Cambridge. When the line opened, traffic developed slowly over a number of years until today's fifteen-minute interval service throughout the daytime. Class 322s, then refurbished 317s, ran the service in the early years until being replaced with the new Class 379 units.

Left: Not being able to get near enough to repeat the above view, this view near to Stansted Mountfitchet station shows the junction signal for the route to the airport and the Down goods loop. 70 mph turnouts are provided for the airport, allowing line speed to be maintained. (Andy T. Wallis)

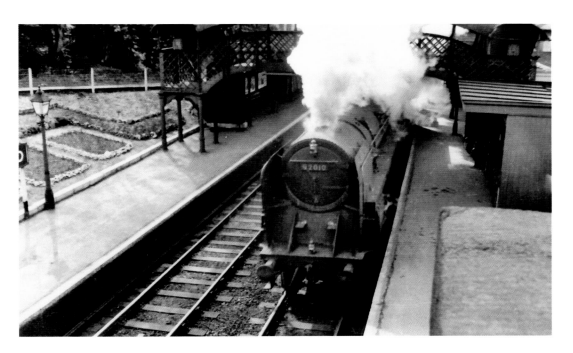

A 1955 view of Class 9F freight locomotive 92010 running through the station, as seen from the station overbridge. Note the clean and tidy station and associated gardens. (Station UK)

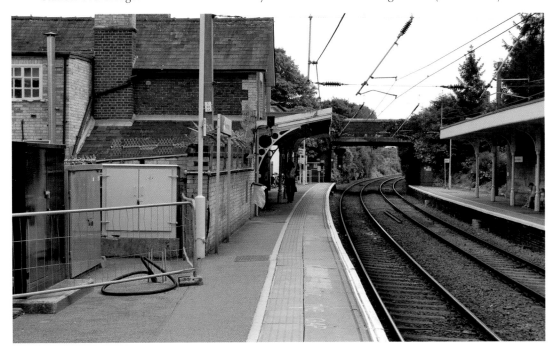

Today the view from platform level looking towards Cambridge shows little change to the buildings, although the signal box has long gone. Electrification required the replacement of the old footbridge, as well as the raising of the overbridge parapets. (Andy T. Wallis)

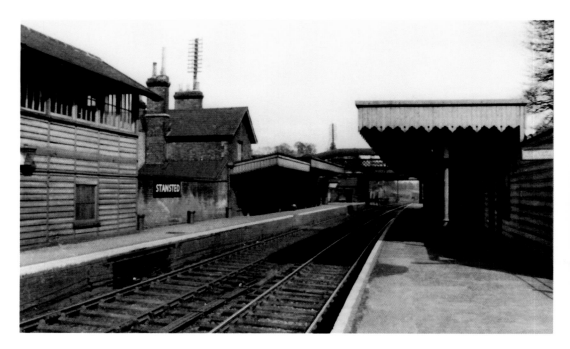

View taken in 1955 from the Up platform showing an overall view of the station, looking towards Audley End and Cambridge. (Stations UK)

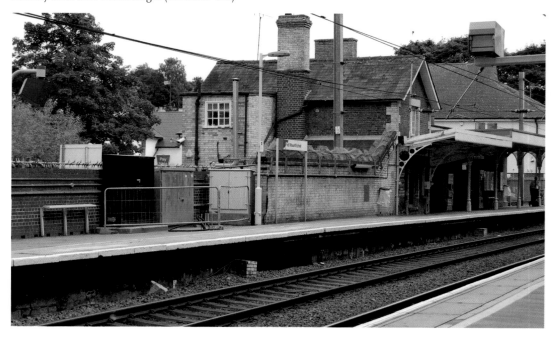

Today the signal box has gone, but the hole in the platform where the wires and rods exited from the signal box can be clearly seen, the actual structure being where the metal equipment boxes are now located. The platform has been raised to the standard height with new edging slabs. (Andy T. Wallis)

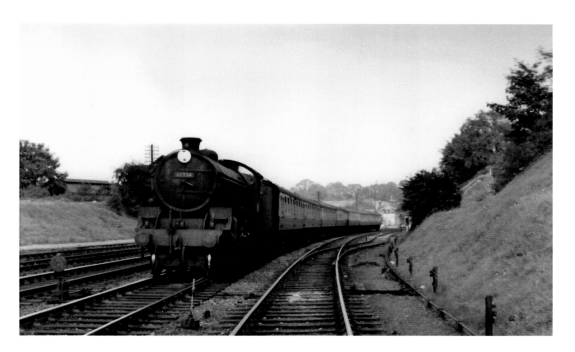

Locomotive B1 61334 departs from Stansted past the Up sidings with a local London-bound service on 8 September 1956. The Up sidings lasted until April 1966, when they were abolished and lifted. (R. C. Riley/Transport Treasury)

Today the platform has been extended over part of the former sidings, and this view is taken in roughly the same position as the previous one. As can be seen, both platforms have been extended to take twelve-coach trains, and the former goods yard has been turned into a car park. (Andy T. Wallis)

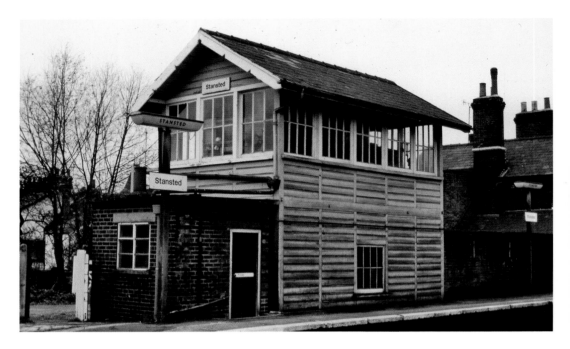

Two views of the old signal box taken in January 1983, a few months before the box closed. The signal box contained a twenty-two-lever Saxby & Farmer frame with all the levers working in the 1950s; by the late 1970s this was reduced to sixteen working levers. Oil trains regularly used the sidings adjacent to the goods yard throughout the 1970s. In the latter days the box was only open for a twelve-hour shift from 7.00 a.m. to 7.00 p.m., Monday to Friday, and was normally switched out during the weekends, as it was on the occasion of these photographs. (Mick Barnes)

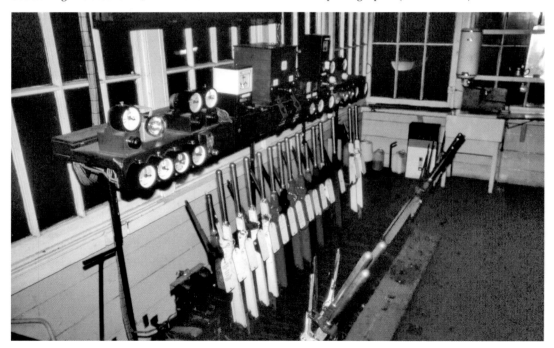

Fullers End Level Crossing

Class 31 diesel powers up the gradient towards the summit at Elsenham station with a Liverpool Street to Cambridge working in 1979. This view was taken from the crossing-keeper's hut; at this Fullers End was a public road crossing, open between 6.00 a.m. and 10.00 p.m. (Andy T. Wallis)

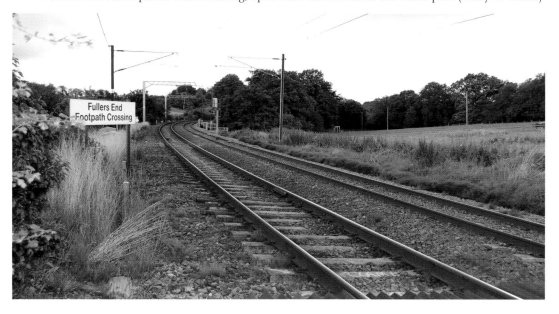

Today the level crossing has been downgraded to a footpath crossing, protected with red and green warning lights. The view looking towards Stansted has not changed much, electrification being the main improvement. (Andy T. Wallis)

A Class 37 diesel glides down the gradient with a London-bound service train in 1979. The level crossing had no protecting signals; the crossing keeper was provided with repeating block indicators to tell him if a train was about. The gates were usually kept closed across the road until a vehicle required to cross.

Today, looking towards Elsenham station, the view is nearly the same except for the overhead wires. The edge of the red and green warning lights is shown, together with the instructions how to use the crossing. (Andy T. Wallis)

Elsenham

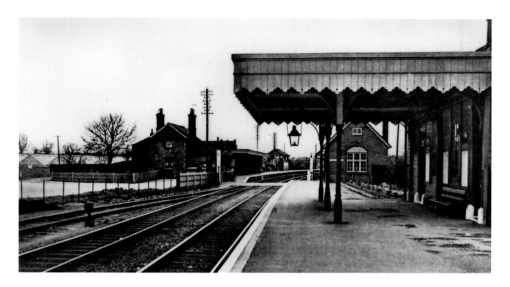

An early 1930s LNER view taken from the Up direction platform, showing the buildings and level crossing. Note the suspended oil lamp under the canopy and the short siding on the left of the Down main line by the level crossing. (Lens of Sutton Collection)

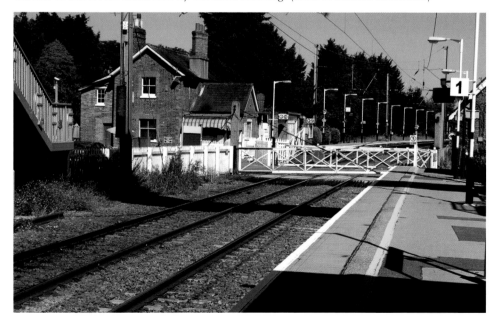

Today, a similar view shows the station house and manual level crossing gates still doing good service. Despite the modern signalling being controlled from Cambridge, the gates were retained due to the peculiar layout of the crossing and surrounding road junctions. (Andy T. Wallis)

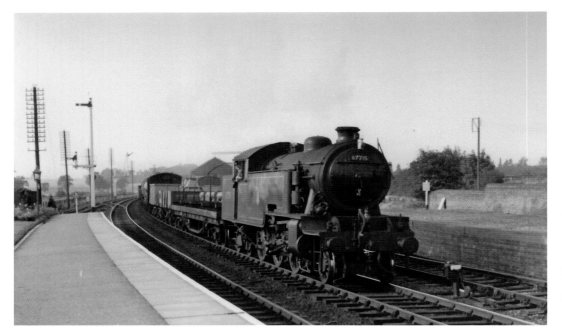

Above: Class L1 large tank engine 67715, hauling a local goods train, passes the Down platform at Elsenham on 8 September 1956. The exit signal from the loading dock and goods yard can be seen just in front of the locomotive. (R. C. Riley/Transport Treasury)

Left: Today, walking to the end of the extended Down platform, the view reveals that the goods loops and yard are all gone, with most of the land sold off for redevelopment. (Andy T. Wallis)

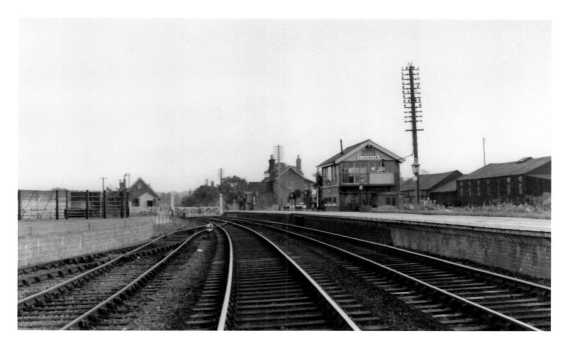

Another 1950s view of the station and signal box, taken from the Up main looking towards Bishop's Stortford and London. The signal box was provided new by the LNER to control the enlarged layout. The line on the far left served the loading dock and the next left is the exit from the Up goods lines or goods shed. (R. C. Riley/Transport Treasury)

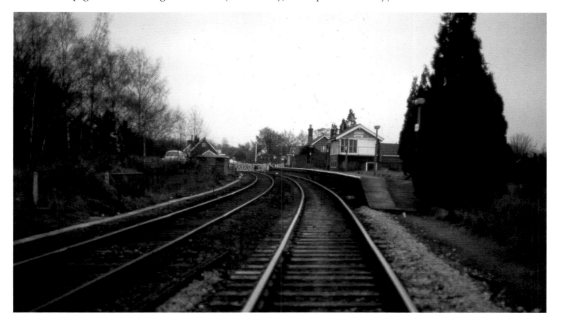

Taken at dusk in January 1983, this view is from the Down main line looking back towards the signal box and station. The former loading dock can be seen covered in undergrowth on the left; all the other sidings and loops were lifted in the 1960s. (Mick Barnes)

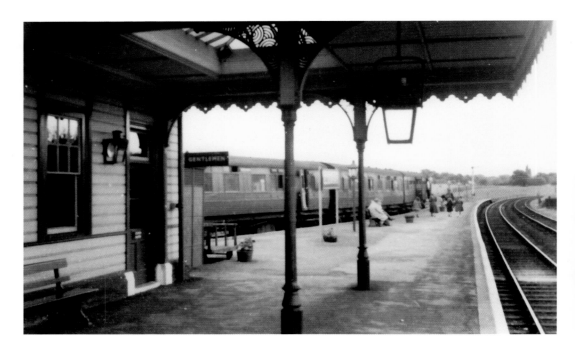

A 1950 view of the Thaxted branch train waiting for the connection to London to arrive. The view was taken from under the station canopy looking south. The signal in the background was the Down home, located on the wrong side for sighting purposes; later this signal was replaced with a 30-foot, tubular steel upper quadrant signal and was located nearer to the level crossing. (Stations UK)

Today the branch to Thaxted has long gone, and the only clue is the curving edge of the platform and a great mound of bushes and trees growing where trains once ran. (Andy T. Wallis)

Inside view of Elsenham signal box taken in January 1983. The LNER had provided a new signal box to work the large layout in the 1930s; the goods yard and goods loop closed in the 1960s, leaving only eight working levers in the signal box at the end of its working life. (Mick Barnes)

In December 1983, a day after the signal box closed, members of the Colne Valley Railway Preservation Society are busy dismantling the lever frame for transportation. The frame was purchased from British Rail for £100. Also, three of the semaphore signals were saved for reuse and they cost £25 each. (Andy T. Wallis)

The platform-mounted, LNER-provided signal box at Elsenham, seen here in January 1983. The lever frame was mounted at the rear of the box and a coke stove was provided for heating, with a sink and drainage board provided near to the door. The small brick hut to the right of the signal box was the battery room, providing power for the repeaters and block controls. (Mick Barnes)

Today there is just a mound of earth where once the box stood. The fir trees seen in the earlier view have all grown considerably in the last thirty years. (Andy T. Wallis)

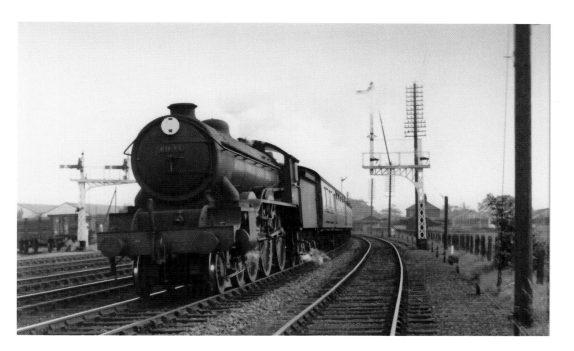

Locomotive B2/17 61633 departs from the station. This view was taken from the Down goods loop looking back towards the station. The signal on the right is the Up home signal, located there as there was no room between the Up main line and the Up goods loop for a conventional position. (R. C. Riley/Transport Treasury)

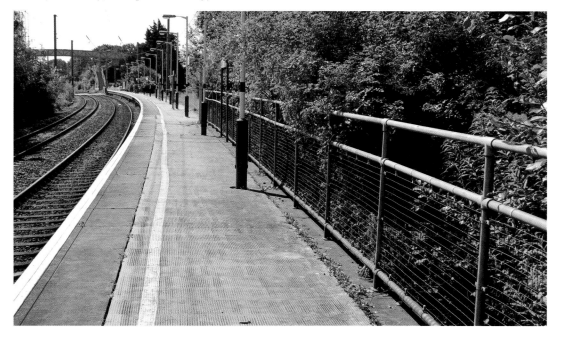

Today the platform has been extended over part of the Down goods loop/siding. This was the nearest one could get to the previous view. (Andy T. Wallis)

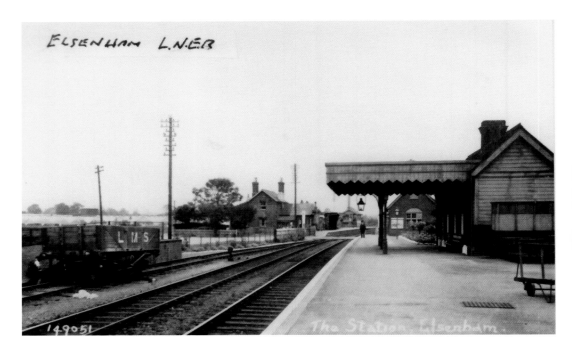

A London & North Eastern (LNER) view, taken in the 1930s, looking towards Newport and Cambridge from the Up platform; visible are the waiting room, canopy, ticket office, station house and level crossing. A solitary LMS wagon stands in the siding awaiting collection. (Lens of Sutton Collection)

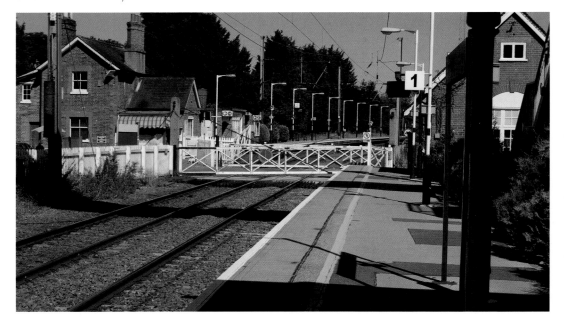

Viewed today from under the canopy, very little seems to have changed. The signal box has gone, closed in December 1983, and the siding has also been lifted, but the gates remain guarding the level crossing, worked by a crossing-keeper. (Andy T. Wallis)

Newport

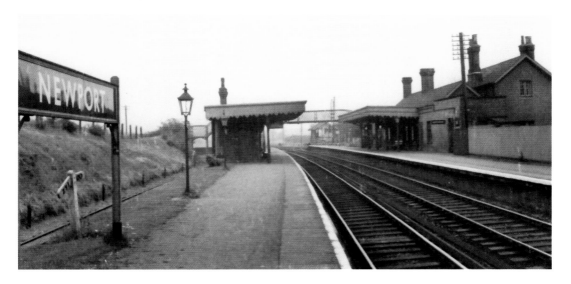

A 1958 view of Newport, looking south towards Bishop's Stortford and London. A refuge siding ran behind the platform, and the footbridge had an extra piece on it to pass over this siding. The station had a signal box at this time, later destroyed in a shunting accident; a small switch panel was provided as a replacement until the 1983 resignalling. (Stations UK)

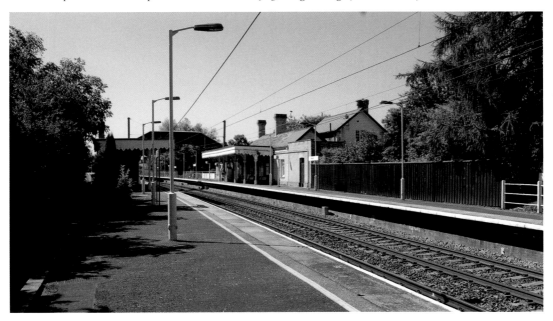

Today the station buildings have changed very little, still providing good service to the travelling passenger. The refuge siding has long gone, and the footbridge has been replaced to provide electrification clearance. (Andy T. Wallis)

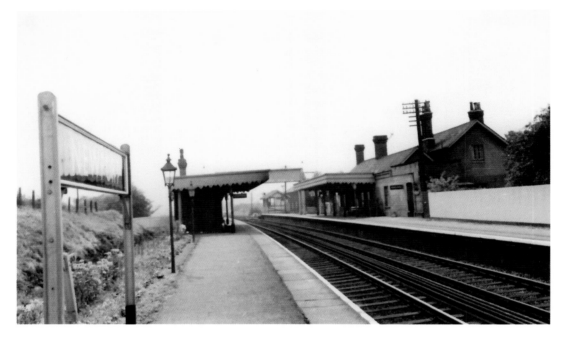

A similar view to the previous one shows changes that have taken place since 1958. By 1964, the Up refuge siding had been lifted and the space was slowly being taken over by vegetation. The footbridge had been changed, with a new centre section, and the extension over the siding had been removed. (Stations UK)

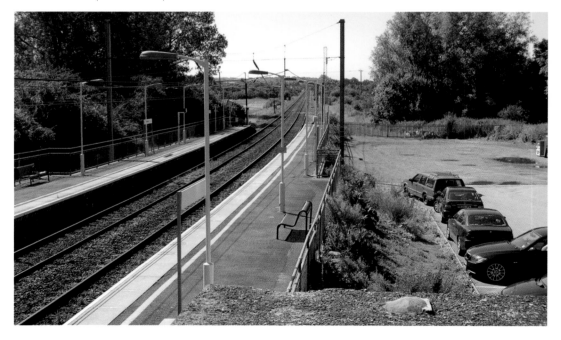

Instead of the same view as on page 85, this is the view looking south from the steps of the footbridge. The goods yard has been lifted and given over to car parking. (Andy T. Wallis)

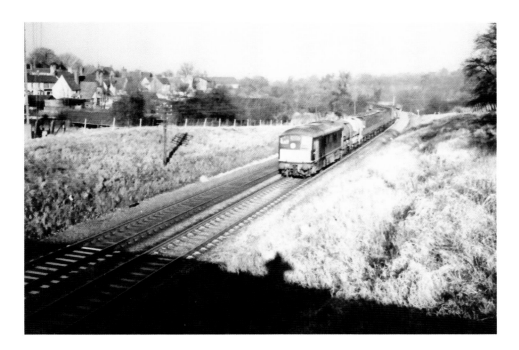

Class 25 diesel on a local freight working, approaching Newport. Seen here in the spring of 1970 was a local Speedlink service that replaced the local pick-up goods service. It would be another twelve-plus years before this part of the line was modernised and electrified. (Brian Barham)

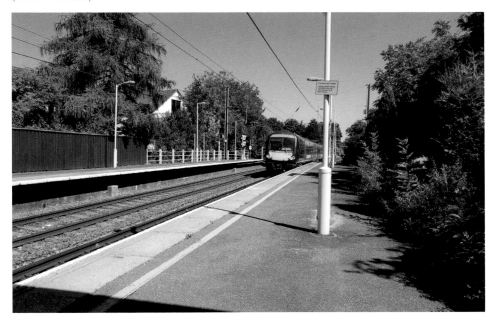

Unable to get the same view due to high bridge parapets and vegetation growth, this view is taken from the Up platform as a Class 170 DMU races through with a train to Stansted Airport. (Andy T. Wallis)

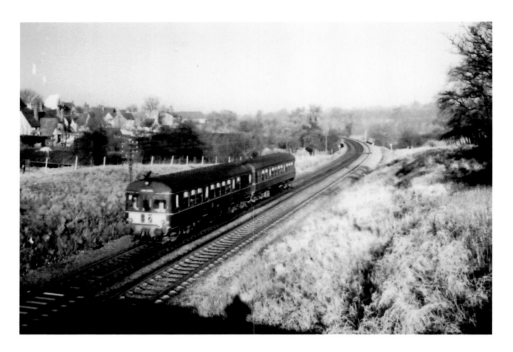

In the spring of 1970, a Wickhams DMU is seen on a local Bishop's Stortford to Cambridge service just to the north of the station. Newport village can be seen to the left of this view. (Brian Barham)

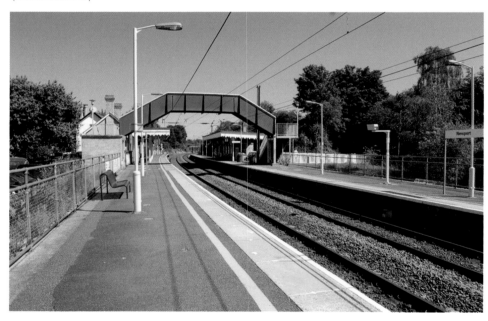

A general view of the neat and tidy station, looking towards Cambridge from the extended Down platform. The replacement footbridge can be seen. Electrification from Bishop's Stortford to Cambridge took place in the mid-1980s after the line had been resignalled. (Andy T. Wallis)

Audley End

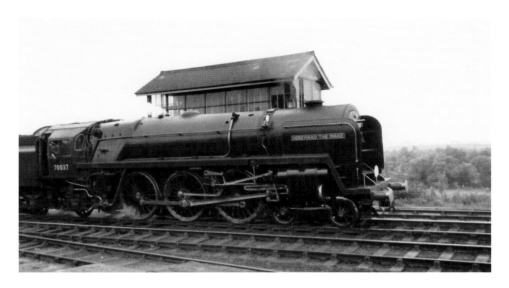

Britannia Pacific 70037, named *Hereward the Wake*, passes the signal box on 24 July 1955. The sixty-lever signal box is behind the locomotive. This view was taken between the branch and siding at the London end of the station. (A. E. Bennett/Transport Treasury)

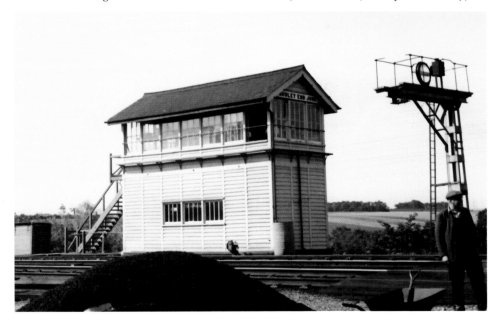

Viewed from the lifted branch siding on 16 August 1968, Audley End signal box is seen with the former Up starting cantilever post, stripped of its signal and now only used for an oil-lit banner repeater. By 1969, only twenty-five levers were left in working order in the signal box. (D. J. Plyer)

A Sunday view, taken in 1980, looking through the original overbridge northwards towards Cambridge. The signal box was switched out on this day, the platform starting signal showing a nice, clear, green signal. The line to the left under the bridge was the Down goods loop, which survived until resignalling in 1983. (Andy T. Wallis)

Today the bridge has been rebuilt to allow clearance for the overhead power lines, the Up platform has been extended right up to the bridge and all the remaining land has been given over to car parking. (Ray Bishop)

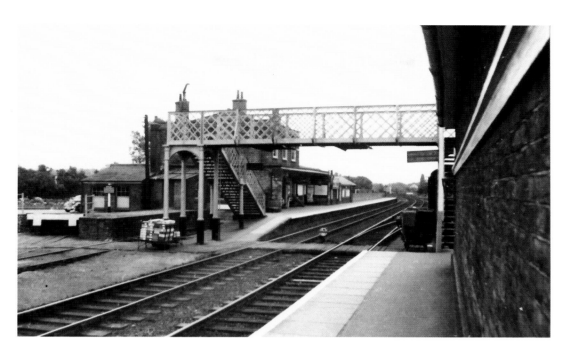

1955 view of the station taken from the Down platform, showing the original lattice girder footbridge and the short length of the original platform. The lines on the extreme left are in the goods yard. (Stations UK)

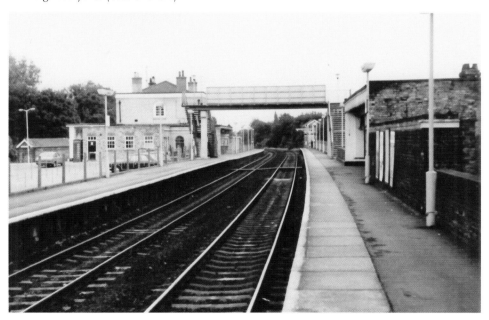

A similar view, taken in 1980 on a quiet Sunday evening, looking towards London from the Down platform. The old footbridge had been replaced with a modern concrete structure and the first extension of the platforms had taken place, the Down platform being extended over the former Down siding. (Andy T. Wallis)

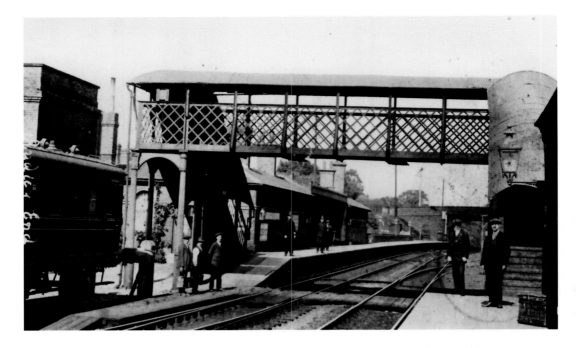

An early Great Eastern view of Audley End, with several staff arranged for this posed shot. The original short length of the platforms can be seen in this view when compared with the next picture. The lattice-work footbridge survived for many more years before being replaced with a modern structure. (Lens of Sutton Collection)

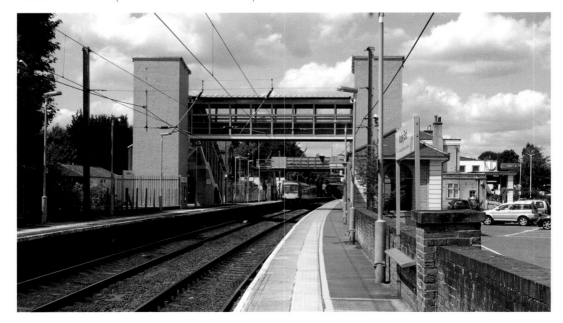

Today both platforms have been extended, and new lifts and stairs have been provided for accessing the Cambridge-bound platform. A Class 170 diesel unit is in the platform. (Ray Bishop)

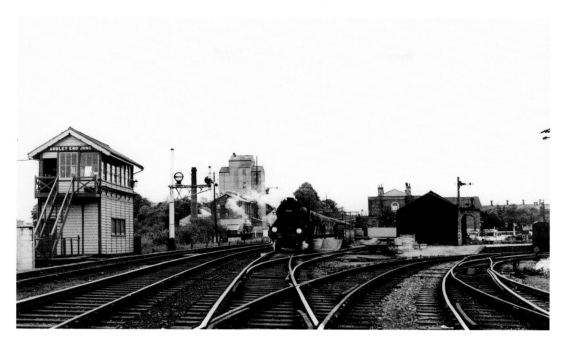

Locomotive B2 61623 prepares to depart for London with an Up express on 26 May 1956. The signal box is on the left, with the branch curving away to right with its separate platform. The main buildings can be seen behind the wooden shed in the middle of the picture. (H. C. Casserley)

By 1968, the branch junction and siding had all been lifted. In this early colour view, the old branch starting signal stands guard over nothing, awaiting demolition. Lifting of the branch commenced in the summer of 1968. (D. J. Plyer)

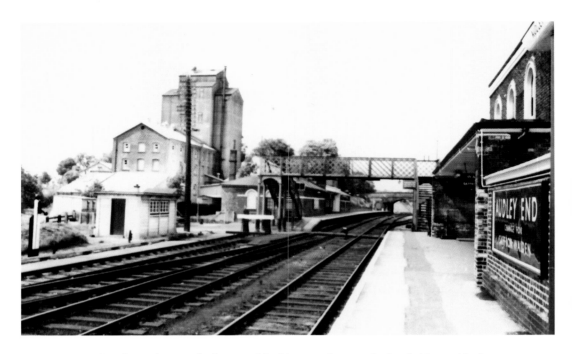

A 1964 view, taken from the Up platform and looking north towards Cambridge, with the name board proudly stating 'Change for Saffron Walden', which would remain true until September of that year. The siding on the left was shortened to allow the first platform extension to take place; it was eventually abolished altogether. (Stations UK)

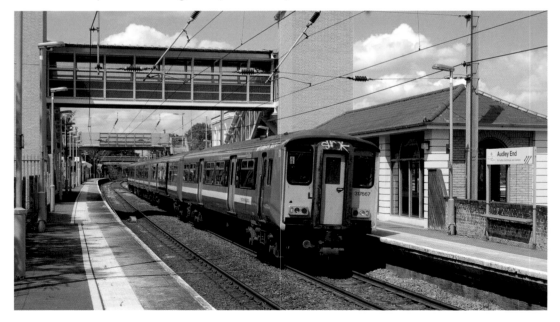

This view, taken from the platform extension, is looking towards Cambridge and shows EMU 317667 arriving with a London-bound service. The new waiting room and lift towers can be clearly seen. (Ray Bishop)

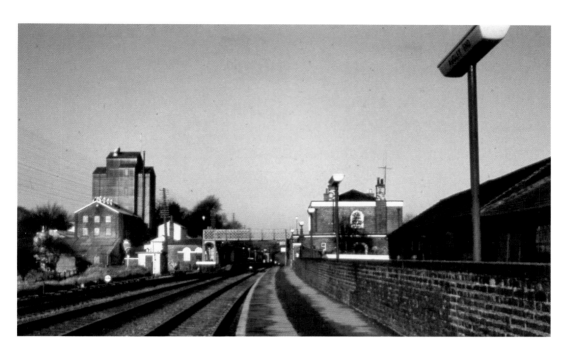

Early colour view, taken in the 1960s, of Audley End station looking towards Cambridge from the Up platform. In those days, the platforms were completely staggered and fairly short in length. The building on the right was served by a short siding off the branch connection; the siding on the left was shortened to allow for platform extensions. (D. J. Plyer)

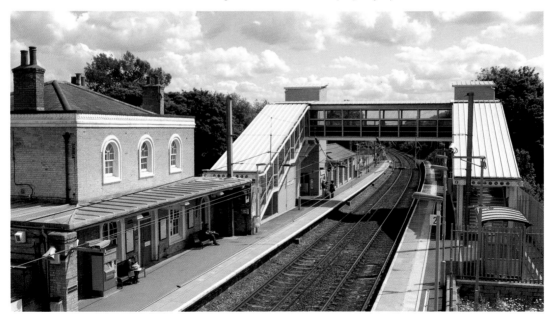

Today, the view from the footbridge looking south shows the new lifts and stairs, installed to allow disabled access to the Down platform. Both platforms have now been extended to take twelve-coach trains. (Ray Bishop)

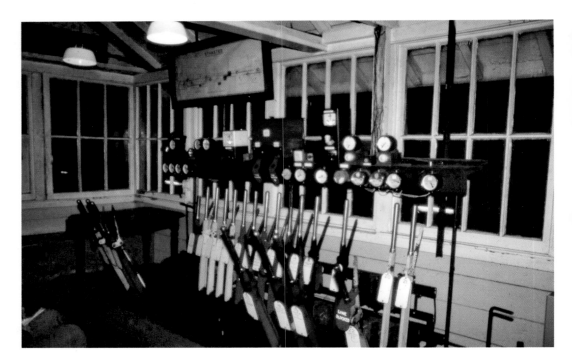

An interior view of Stansted signal box taken in January 1983, just a few months before it was closed in December 1983. The signal box was equipped with a Saxby & Farmer twenty-two-lever frame, of which all were working in the 1950s, but like all stations this was reduced in the 1960s and 1970s to only sixteen working levers. (Mike Barnes)

Acknowledgements

Special thanks to Ray Bishop and Sebastian Sekinger for the provision of the modern images. Once again, many thanks to Richard Casserley for allowing access to his photographic collection and to Mick Barnes, Brian Barham, Nick Ellis, Dickie Pearce, D. J. Plyer, Lens of Sutton Collection, Paul Lemon and the Historical Model Railway Society for help with the archive views. Thanks to all the other photographers and organisations that have provided views from their collections.